APERTURE MASTERS OF PHOTOGRAPHY

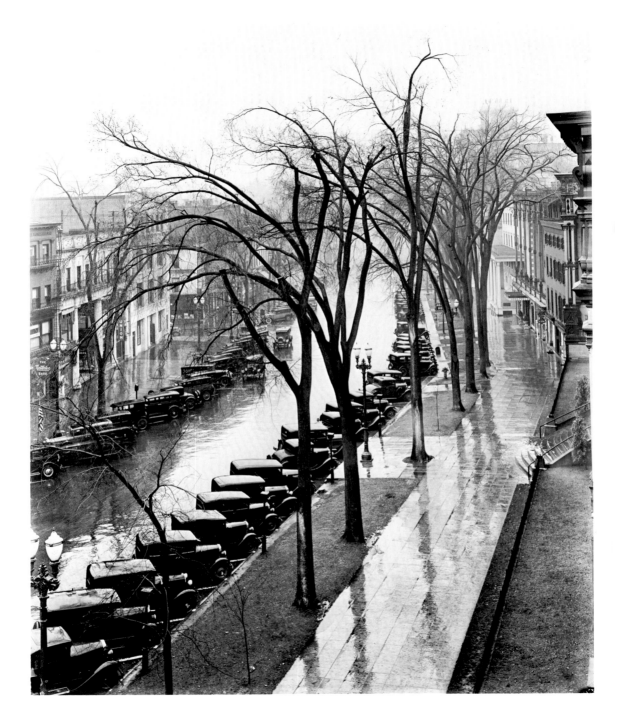

WALKER EVANS

With an Essay by Lloyd Fonvielle

MASTERS OF PHOTOGRAPHY

APERTURE

Printed in Hong Kong
Library of Congress Catalog Number: 93-71083
ISBN: 0-89381-741-4

Aperture Foundation publishes a magazine, books, and portfolios of fine photography and presents world-class exhibitions to communicate with serious photographers and creative people everywhere. A complete catalog is available upon request. *Aperture Customer Service:* 20 East 23rd Street, New York, New York 10010. Phone: (212) 598-4205. Fax: (212) 598-4015. Toll-free: (800) 929-2323. E-mail: customerservice@aperture.org *Aperture Foundation, including Book Center and Burden Gallery:* 20 East 23rd Street, New York, New York 10010. Phone: (212) 505-5555, ext. 300. Fax: (212) 979-7759. E-mail: info@aperture.org *Aperture Millerton Book Center:* Route 22 North, Millerton, New York, 12546. Phone: (518) 789-9003.

Visit Aperture's website: www.aperture.org

Aperture Foundation books are distributed internationally through:
UNITED KINGDOM, EIRE, SOUTH AFRICA: Aperture c/o Robert Hale, Ltd., Clerkenwell House, 45-47 Clerkenwell Green, London EC1R OHT, United Kingdom. Fax: +44 (207) 490-4958. E-mail: enquire@hale-books.com WESTERN EUROPE, SCANDINAVIA: Nilsson & Lamm, BV, Pampuslaan 212-214, P.O. Box 195, 1382 JS Weesp, Netherlands. Fax: +31 (29) 441-5054. E-mail: info@nilsson-lamm.nl AUSTRALIA: Tower Books Pty. Ltd., Unit 9/19 Rodborough Road, Frenchs Forest, Sydney, New South Wales, Australia. Fax: +61 (29) 975-5599. E-mail: towerbks@zipworld.com.au NEW ZEALAND: Southern Publishers Group, 22 Burleigh Street, Grafton, Auckland, New Zealand. Fax: +64 (9) 309-6170. E-mail: hub@spg.co.nz INDIA: TBI Publishers, 46 Housing Society, South Extension Part-I, New Delhi 110049, India. Fax: +91 (11) 461-0576. E-mail: tbi@del3vsmp.net.in

To subscribe to *Aperture* magazine write Aperture, P.O. Box 3000, Denville, New Jersey 07834, or call toll-free: (866) 457-4603. One year: $40.00. Two years: $66.00. International subscriptions: (973) 627-2427. Add $20.00 per year.

K2 K4 K6 K8 K7 K5 K3

Walker Evans's manifold portrait of America defies the ordinary categories of photographic criticism. There is certainly no other body of American photographs quite like it. We must look elsewhere —to the novels of Melville and Twain, to the poetry of Dickinson and Whitman, to the paintings of Eakins and Ryder — for a native vision of equal integrity and excellence.

The word *epic* once referred strictly to a kind of high narrative poetry derived from the common heart and mind of a people. Evans's work is best understood as epic in that sense. He appropriated the potent, head-on style of naïve vernacular photography and transformed it into an instrument of conscious elegance. He used it to extract from the mundane fabric of America images of its brute innocence, exemplary craft, pathetic self-deception, and persistent nobility. He pursued, systematically and boldly, a poetic definition of the American experience. He worked in series, with a storyteller's gift for narrative rhythm and suggestive detail. His range was awesome.

Walker was born in St. Louis, Missouri, on November 3, 1903, the son of Walker and Jesse (neé Crane) Evans. Though the family soon moved to Toledo, Ohio, and finally settled in an affluent suburb of Chicago, Evans seems never to have lost that insight into mainstream America peculiar to artists, like Twain and Faulkner, with roots close to the banks of the Mississippi River. Evans's ability to conceive the nation as a complete and unique phenomenon was undoubtedly reinforced by his subsequent move as a youth to New York City, where he accompanied his mother after his parents' separation.

From New York, Evans attended Phillips Academy in Andover, Massachusetts, one of the venerable Eastern preparatory schools. The European discipline and tradition of Andover must have further elaborated his perspective on the American heartland. It also gave him a ground of shared experience with the most crucial artistic and spiritual peers of his later life, Lincoln Kirstein and James Agee, both products of similar New England institutions.

After graduation from Andover, Evans attended Williams College for a year and then dropped out. His natural restlessness was clearly aggravated by vague artistic impulses, because he took himself off to Paris, nominally to audit classes at the Sorbonne but actually to read on his own in French literature and to experience at first hand the intellectual industry of Paris in the twenties.

Evans lived the life of a bohemian expatriate on a small allowance from his father. He did not engage

personally with the great figures of literature and painting who were gathered in Paris in 1926, but he was caught up in the artistic adventure and ambitiousness of the place and the time. He wanted desperately to become a writer. The very intensity of his desire betrayed him at once into self-consciousness and pretension, and he abandoned literature in despair over ever achieving in that form the excellence he always demanded of himself. He also considered a career in painting and rejected it for much the same reasons.

After a year or so in Paris Evans returned to New York and worked in a series of short-lived jobs, including one on Wall Street. He had experimented with photography before this time; he was now about to take up the medium in earnest. His discoveries and disappointments in Paris played a crucial role in the decision.

On the one hand, Evans had been tremendously inspired by certain French writers — especially the poet Baudelaire. He saw in the camera a means of adapting the poet's vision to his own ends. Baudelaire's stance as a passionately concerned yet resolutely detached observer, his capacity for moral indignation tempered with a deep fatalism, have their equivalent qualities in Evans's photography. And Baudelaire's keen interest in the physical face of a modern, rapidly urbanizing society is reflected in Evans's decision to record the commonplace minutiae of contemporary America as a key to the spiritual temper of his own steamrolling nation.

On the other hand, Evans had come face to face in Paris with his own deep insecurities about art.

Like many Americans of genius before him, Evans seems to have been terribly uncomfortable in the role of artist; he seems to have felt inadequate to the traditions, mostly European, that he particularly admired. The still camera, by its relative newness as a serious artistic tool, freed him from this haunting specter, as movies had freed the prodigious genius of D.W. Griffith —who insisted on thinking himself a poet and playwright temporarily slumming in the film industry. And the camera, as Evans would use it, offered a direct engagement with the actual and tangible, which could serve as a bracing antidote to the embarrassing refinements of aesthetic calculation.

Evans came to photography, then, with a poet's vision and a prizefighter's appetite for contact — attributes which defined his photographic style almost from the beginning.

There were a few false starts. Evans's early efforts with a camera betray lingering painterly ambitions, similar to those of Stieglitz and the school of pictorial photography he encouraged. Evans would later say that he forged his personal style in direct opposition to the formal tactics of Stieglitz, and one recognizes in his mature work the essential truth of this analysis; but Evans's first published photographs, illustrations to his friend Hart Crane's *The Bridge,* have the forceful, almost theatrical drama of Stieglitz's pictures; they try for the same brooding atmosphere and bold design that attracted so many art photographers of the day. But Evans's flirtation with pictorialism was brief; it did not survive his association with Lincoln Kirstein, one of the few personal or contempo-

rary influences that Evans wholeheartedly acknowledged.

Kirstein, whose ubiquitous midwifery is traceable through so much that is fine and indispensable in twentieth-century American culture, was an undergraduate at Harvard when Evans met him, among a circle of intellectuals presided over by Muriel Draper. Evans later said that Kirstein offered him an articulate aesthetic rationale for his image making, his visual understanding of America. From Kirstein's own writings, it is reasonable to infer that this rationale contained a persuasive apology for photography as an enterprise informed by but not dependent on the strictures of painting — a notion that accorded well with Evans's truest instincts about the medium.

In the winter of 1931 Kirstein proposed a plan to record the surviving Victorian architecture of Boston and in the spring of that year assisted Evans in carrying the project out. Kirstein's practical aid as a guide to this neglected (and once fashionably despised) branch of American building was undoubtedly of less importance to Evans than the example of Kirstein's disciplined intellect, his capacity for excitement over the lessons of tradition, his conception of the past as a dynamic incitement to new, living art.

Most of the Boston photographs did not satisfy Evans in purely photographic terms, but clearly he was approaching a turning point. By the time he began his extraordinary work for the Farm Security Administration, in 1935, the many influences on his personal style had been assimilated and transcended.

The graphic calculation of Stieglitz had given place to a simple, straightforward symmetry in composition, similar to the style of Brady, Gardner, and O'Sullivan — whose work Evans had come to appreciate through the enthusiasm of Kirstein. But Evans's framing was tighter and surer than that of his nineteenth-century predecessors, defining ever more discrete photographic subjects: details of architecture and handicraft side by side with wider views. The wider views themselves had a strict and deliberate irony only occasionally found in nineteenth-century documentary photography. Evans had already begun to analyse the visual incongruities of the American landscape — rusted auto bodies in a pastoral farmyard, rows of factory workers' houses built up next to rows of tombstones, crude handlettered signs tacked onto gracious (and crumbling) old buildings.

The genteel, picturesque poverty depicted in the images of Atget, whose work he also encountered in the early thirties, had occasionally attracted Evans as subject matter but this, too, gave place in his work to images of another kind of poverty, less romantic and more essentially American: the persuasive cultural poverty of a newly made nation. It was a poverty deeply unaware of itself and all the more heartbreaking for that.

This particular evidence of American innocence might almost be said to constitute the core of Evans's vision; it certainly accounts for the disquieting, melancholy aura of his best images. We encounter it throughout his oeuvre — in the rude and often weirdly beautiful American adaptations of European architecture, in the pathetic attempts

at interior decoration by the use of tacked-up photographs and magazine illustrations, in the garish proliferation of advertising into every corner of the American environment. These visual platitudes, almost too common to be noticeable, even today, take on a tragic grandeur in the flowering of Evans's art that dates from the middle thirties.

Evans began work for the government's Farm Security Administration (originally the Resettlement Administration) late in 1935. The agency had embarked on its legendary photographic survey of rural America, and Evans believed he was being hired as a "roving social historian." In fact the project was rather pointedly political, as John Szarkowski has noted, designed to "explain and dramatize the plight of the rural poor to the urban poor — and thus help preserve the tenuous coalition which had brought the New Deal to power." This spirit is quite obvious in the work of some FSA photographers — Dorothea Lange, for example, whose artful sentimentality has often the flavor of propaganda. But Evans had a purer notion of his job, and he followed his own lights.

His personal habits of independence and his sometimes patronizing insistence on his own integrity eventually brought him into conflict with Roy Stryker, organizer and director of the survey, who had more faith than Evans in the possibility of a collective vision. When the FSA budget was tightened in 1937 Evans was, predictably, one of the first to go. But time has brought Evans an ironic vindication. The FSA photographic survey is admired today as a magnificent achievement of social history, and Evans's work stands at the heart of it — as its virtual definition and foremost claim to artistic endurance.

Evans photographed for the FSA a wide range of subjects, invariably executed in series: a sequence of views of Pennsylvania mining towns, a sequence illustrating the effects of soil erosion, a sequence depicting black neighborhoods in various Southern cities. The relevance of these documents to the social and economic realities of the time is obvious; but Evans always tempered his social conscience with an aristocratic relish for any evidence of nobility or grace, however unconscious, in the man-made environment. He once told an interviewer, "I guess I'm deeply in love with America," and it is clear that he loved it, even in its worst deficiency, not in spite of itself but in profound sympathy with its most basic aspirations, damaged and hopeless as they might be.

This sympathy was compounded by a natural respect for all people and all testaments to honest labor, however mean. Before he joined the FSA he had taken a series of pictures for Carleton Beals' book *The Crime of Cuba,* and even these images of a truly desperate poverty accord their subjects a distance and dignity that remains almost without parallel among photographic documents of human misery. Evans always avoided devices of outright emotional appeal, but he thereby made it possible for his plain, self-effacing records to convince and move the viewer on a level of serious moral reflection and concern.

In the summer of 1936 Evans took a leave of absence from the FSA to work on an ostensibly

commercial assignment. James Agee, who had met Evans earlier in Greenwich Village, was then working on the staff of *Fortune* magazine and had been assigned to write an article on Southern tenant farmers, a prospect that fired his imagination to the height of its considerable power. He requested Evans as photographer for the project.

Agee plunged into the work with a resolute, defiant irresponsibility toward the needs of a magazine like *Fortune*. What emerged from the assignment was not any sort of usable piece of journalism, or fragment thereof, but a book-length treatise, eventually published in 1941 (and reissued in 1960) as *Let Us Now Praise Famous Men*.

The text is an extended meditation on morality, perception, the limits of language, and the deceptions of art, all unified by elaborate descriptions of rural poverty executed with surgical precision and lyric genius. It contains the best of Agee's magnificent prose, as well as jarring passages of adolescent self-indulgence, self-pity, and pretension. The result is a work of maddening, frightful inspiration, a masterpiece by any standards but a masterpiece that parades its flaws with poignant, nearly tragic recklessness.

Evans's photographs for the book constitute one of the most intense and sublime photographic essays ever assembled. Grouped in a section preliminary to the text, they provide a kind of anchor to Agee's roiling and restless sensibility. Evans collaborated with the harsh and magical Alabama sunlight to reveal the weathered boards of simple shacks, the dusty clay of country roads and burial grounds, the devastating openness, or grave pride,

or shamed hurt on the faces of the tenant families. The images are disarmingly quiet, with an unsettling insistence that explains and justifies Agee's despair over the possibility of evoking their intricate ambiguities in words.

Evans said that Agee delved intimately into the lives of the tenant farmers, while he stood back, kept his distance, made his records from a more reticent vantage. Yet one cannot overestimate the effect of Agee's engagement on Evans's achievement in *Let Us Now Praise Famous Men*. Once again, as with Kirstein, Evans responded to the example of a first-rate, focused intellect with a sharpening of his own insights, a refinement of his own vision. The photographs he made in association with James Agee, together with the photographs he made for the FSA, represent the essence, the fulcrum of his life's work. They direct our attention in a literate and orderly way to the precise themes of Evans's whole endeavor.

In this work he claimed the straight photographic document for the highest uses of conscience and art, and in doing so he made it necessary to see all straight photographic documentation, from Mathew Brady to the contemporary snapshot, as a field of moral suggestion and perceptual challenge every bit as crucial as the aesthetic arena of more obviously artistic image making.

The full impact of the achievement is nowhere better felt than in Evans's book *American Photographs,* published in 1938 to accompany an exhibition of his work at the Museum of Modern Art. Most of its images were made under the auspices of the FSA between 1935 and 1937. Their power in

this immaculately constructed collection is of an order not often realized through photography alone. *American Photographs* must be considered not only among the most eloquent photographic books ever published but also among the few genuine classics of American art.

When he had accomplished so much, it is rather astonishing that Evans chose not merely to elaborate on his central vision, to accumulate more and more images using the same formal means—something he might sensibly and honorably have done. Instead he expanded the field of his attention and began experimenting with more flexible photographic equipment. Evans had usually done his work with a large-format view camera, occasionally supplemented by smaller hand-held models. In the late thirties, he started to employ the small camera for projects specifically suited to its use.

The most important of these was a series of portraits of New York subway riders taken with a small Contax camera hidden in his overcoat. Using only available light, he collected a variety of tense, weary, or vacant faces that nevertheless seem to glow in the dreary gloom of the underground trains. Indeed they evoke with uncanny exactness Pound's famous poem *In a Station of the Metro:* "The apparition of these faces in the crowd;/Petals on a wet, black bough." Formally the photographs do not vary; they lack the tactile and tonal richness of Evans's more typical work. But the variation among the expressions and among the physical features of the faces is consequently thrown into high relief, and their accumulation in series sug-

gests a rare intensity of pity and identification and, as always with Evans, exalted wonder. (A selection of the subway portraits, made in 1938 and 1941, was published in 1966 as *Many Are Called.*)

Evans also made a series of candid portraits of pedestrians on the streets of Chicago and later, for *Fortune* magazine, recorded in 35mm the passing American landscape from the window of a moving train. Many of these last images were done in color, and toward the end of his life Evans began taking instant color photographs using Polaroid's compact SX-70 camera.

Evans's achievements in small formats and in color would exert a decisive influence on the whole modern style of documentary photography, through the work of such seminal figures as Robert Frank and Lee Friedlander — both of whom were close friends of Evans in his later years.

Evans's career after his FSA association is unusual in the annals of American art. After accomplishing works of genuine greatness he suffered no tragic decline, made no commercial capitulation, began no process of artistic self-cannibalization. In 1942 he published, as illustrations to Karl Bickel's book *The Mangrove Coast,* one of his most balanced and satisfying photographic series: views of the west coast of Florida that comprise landscapes set side by side with details of the eccentric human intrusions into this haunting stretch of seashore and swamp. From 1943 to 1945 he worked as a book reviewer for *Time* magazine, at last fulfilling, if only indirectly, his youthful literary ambitions. But he said the job "drained him dry" and he

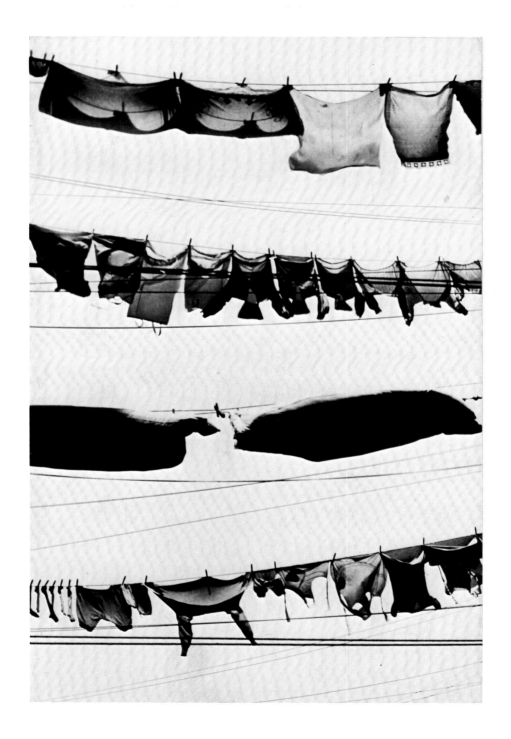

subsequently moved over to *Fortune* as the magazine's only staff photographer.

The job title is misleading, though. Evans was more of an independent editor, who initiated his own projects, assembled, and designed his own pictorial layouts and often wrote his own accompanying texts. (He was eventually accorded the title associate editor at *Fortune*.) Unlike Agee when he worked for the magazine, Evans was free to follow his own inspirations entirely, within only the vaguest limits of editorial direction. It was a perfect situation. Evans stayed at the job for twenty years and produced some of his best photographs.

Of course only a fraction of the images Evans made for *Fortune* were ever published. Some of the work that did appear, like the series of views from train windows, is unusual and exciting, especially for its pioneering work in straight color documentation. Much of the unpublished work is now being catalogued for the first time, and there lies before us the happy prospect of discovering new dimensions to Evans's already prodigious oeuvre.

Evans left *Fortune* in 1965 to become a professor of visual studies at Yale University. His wit, his retiring manner, and his native skepticism kept him from becoming the grand old man of American photography, a role he might easily have taken for himself with only a bit of presumption and self-publicity. Instead he talked quietly with small seminars of students, lent his mere presence to whatever uses as inspiration or example it might serve, and went on making photographs. He lived to see his work widely acknowledged and appreciated, and he died in 1975 at the age of seventy-one.

Walker Evans, at a comparatively early age, found himself possessed of a vision of America, a sharp insight into its grandness and sadness, its awful dreariness and its lyric, redemptive simplicity. He came upon a means to serve that vision, to transcribe it mechanically into immovable images and then into more articulate and livelier series, whose meanings are at least partly accessible to the rest of us. Like the best of servants Evans held a conviction of mission amounting to arrogance, but this sureness kept him to his task over the course of many remarkably productive years.

Most of the master documentary photographers have been amateurs or unself-conscious journeymen transforming private, inchoate obsessions into the rarest and most precious glories of the genre. With Evans, however, documentary photography came under the sway of a genuinely literate, subtle, and self-aware mind, an ordered and reasoned artistic imagination. The difference his awareness makes is there to be seen in the photographs, in the series especially, in the life's work unmistakably.

He created with measured proportion and tact, with authority and finality, a genuine epic exaltation of this people and this land. As we can say of the greatest epic poets, his nation has received a true measure of its identity through the faithful mediation of Walker Evans.

Lloyd Fonvielle

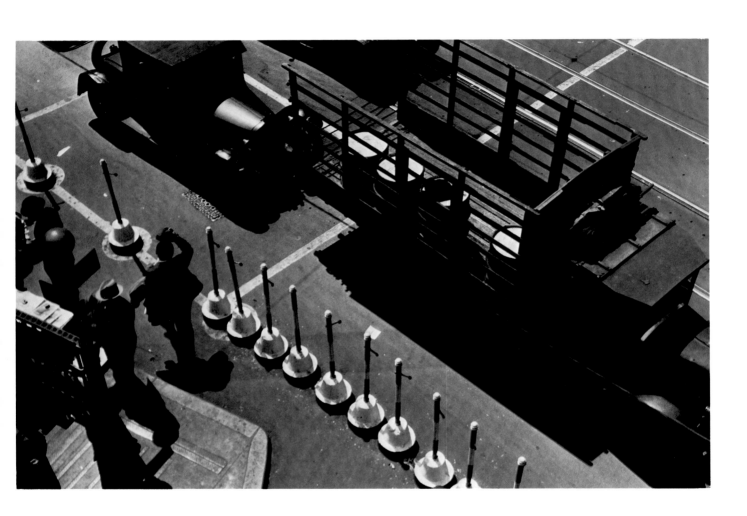

13

Brooklyn Bridge, New York City, ca. 1929

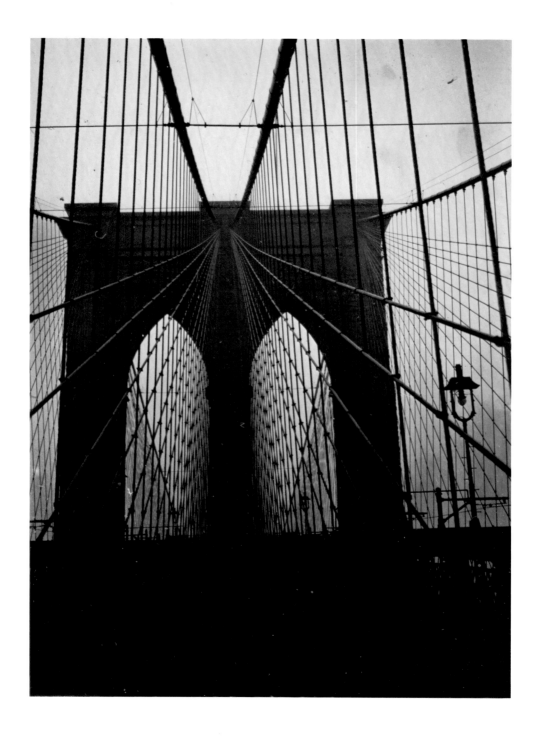

South Street, New York City, 1932

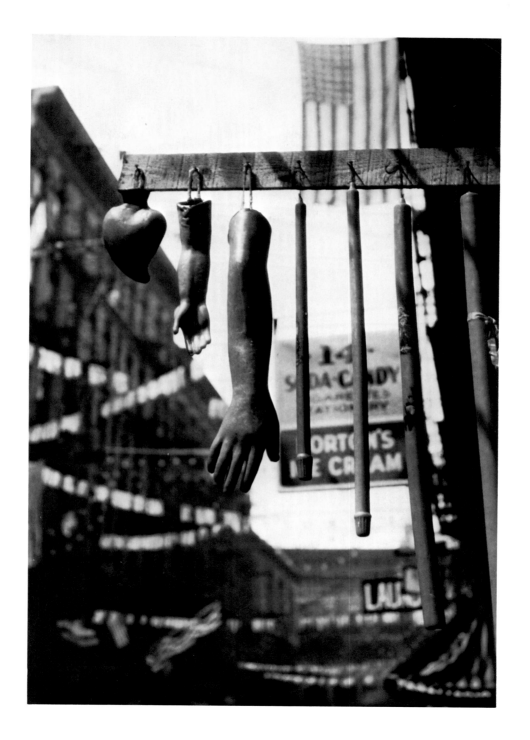

17

Coney Island, 1929

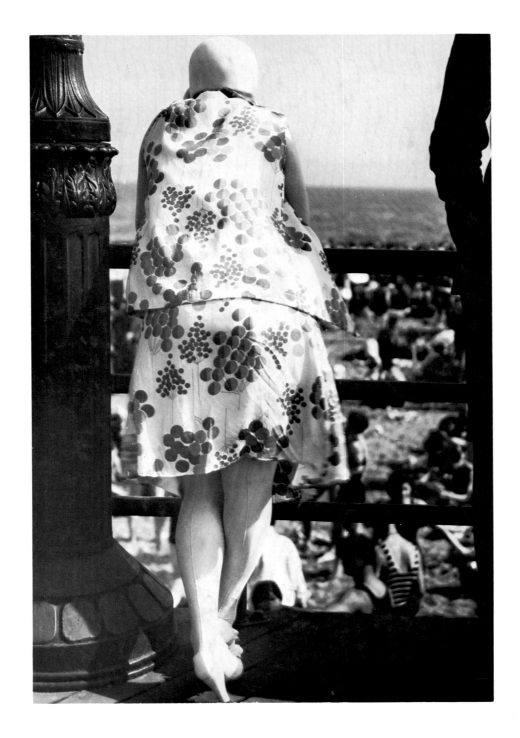

42nd Street, 1929

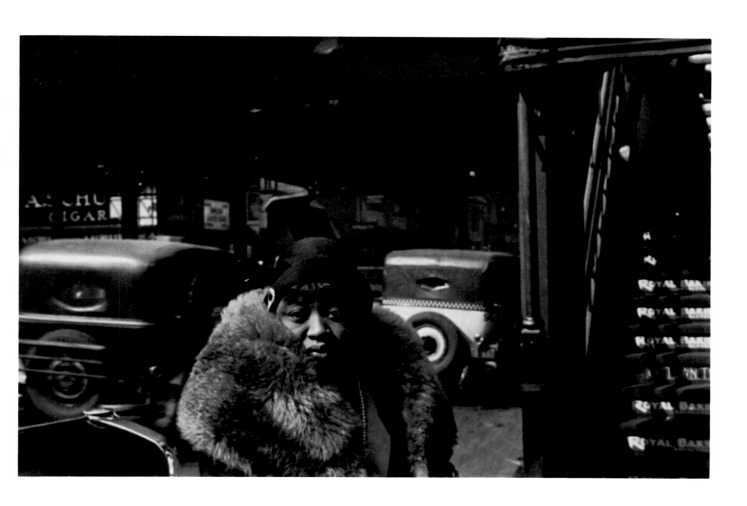

Fulton Street, New York City, 1929

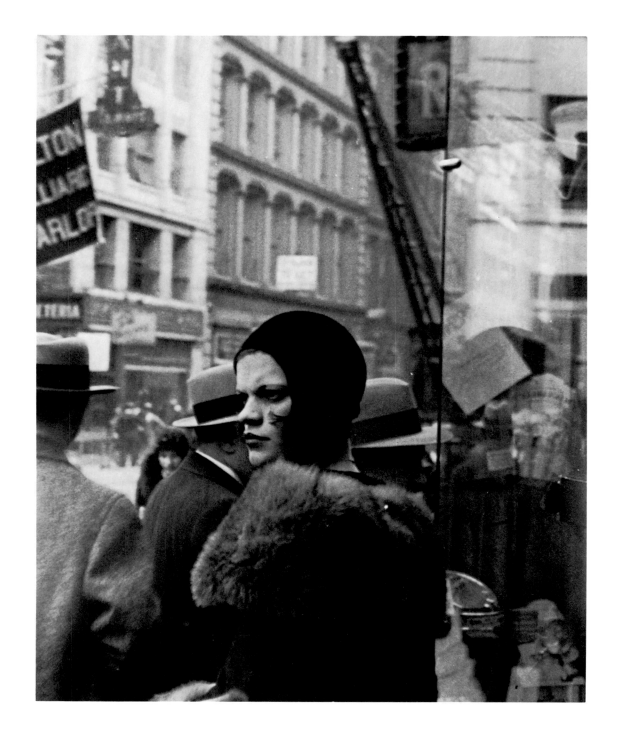

23

Chrysler Building Construction, New York City, 1930

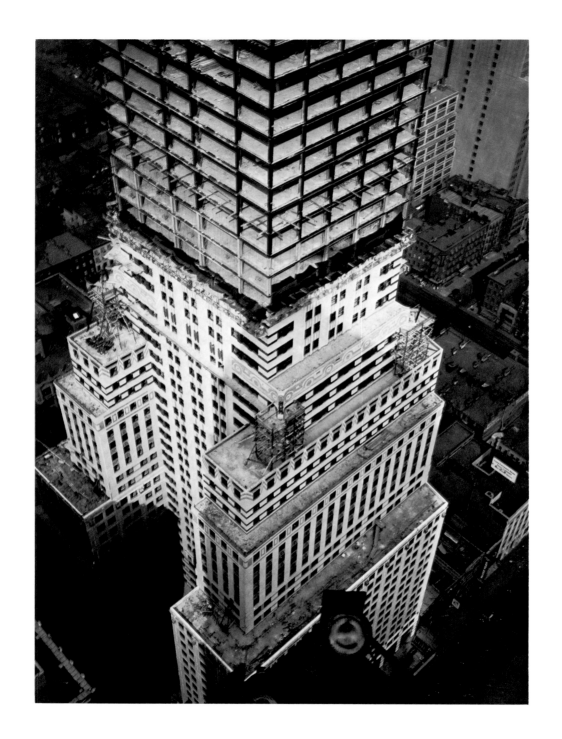

License Photo Studio, New York City, 1934

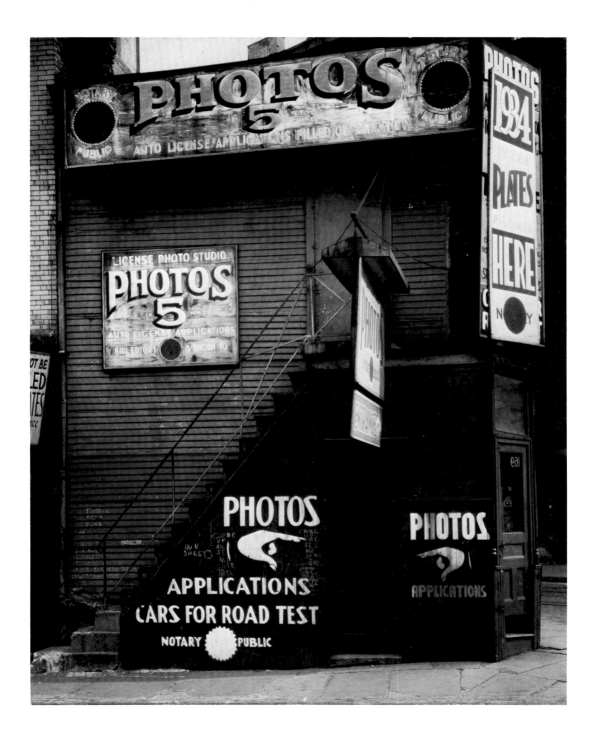

Factory Street, Amsterdam, New York, 1930

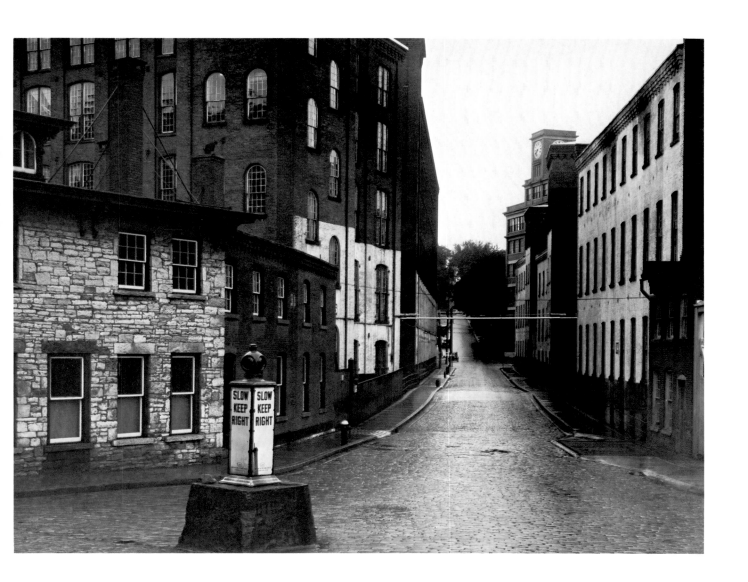

Main Street, Ossining, New York, 1932

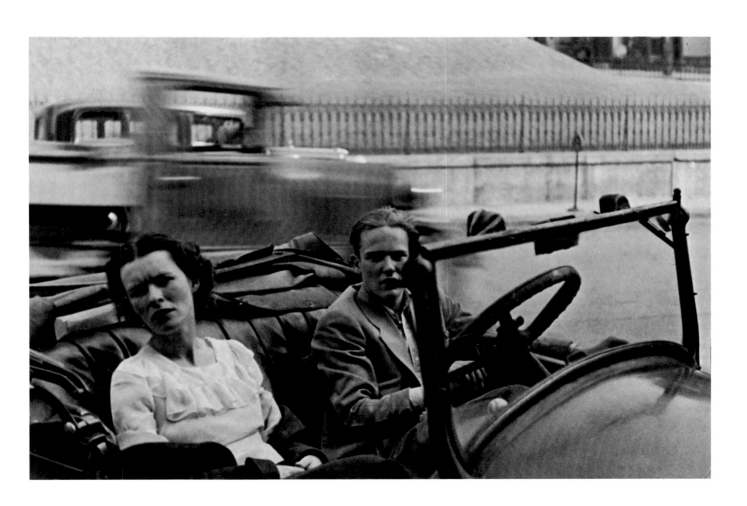

31

Citizen in Downtown Havana, 1932

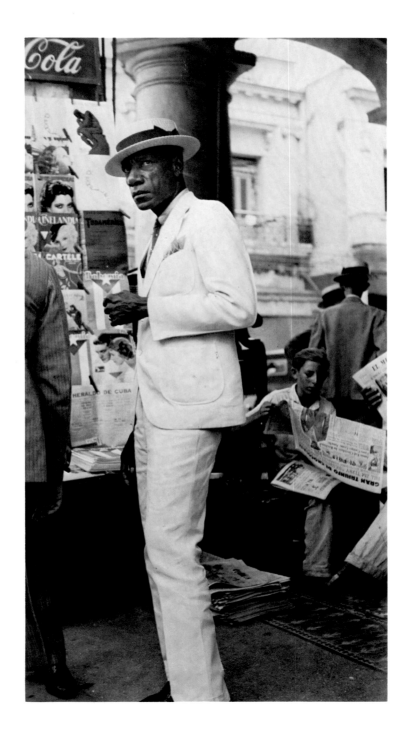

Dockworker, Havana, 1932

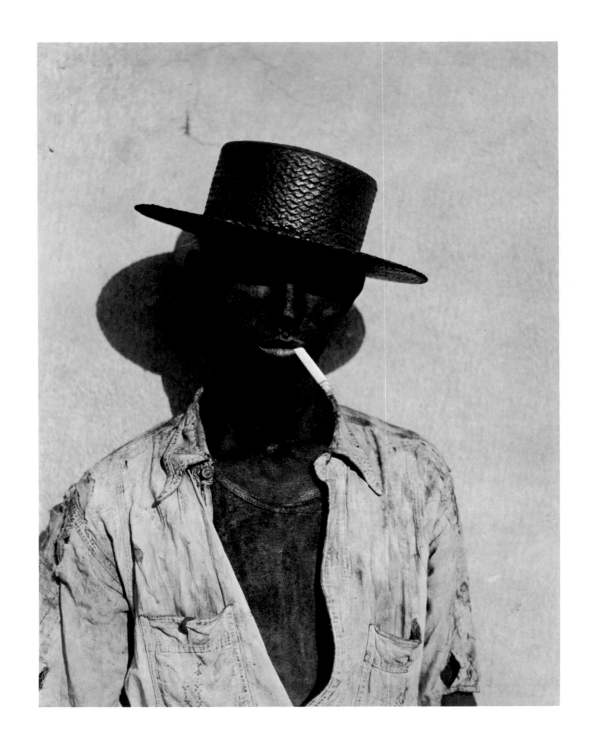

Girl in Window, Havana, 1932

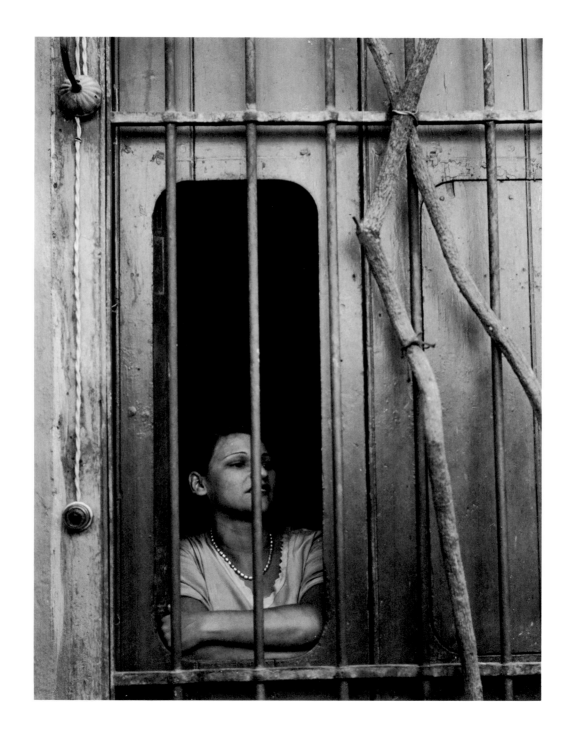

Westchester, New York, 1931

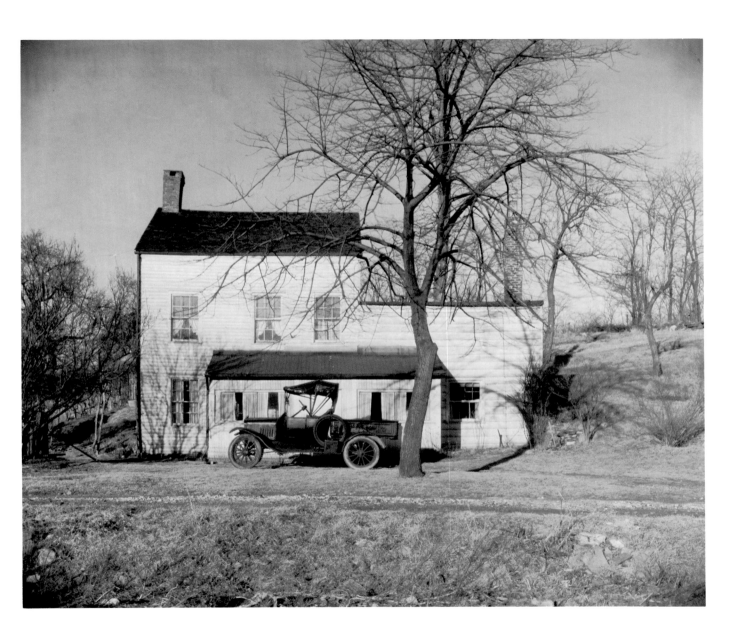

Political Poster, Massachusetts, 1929

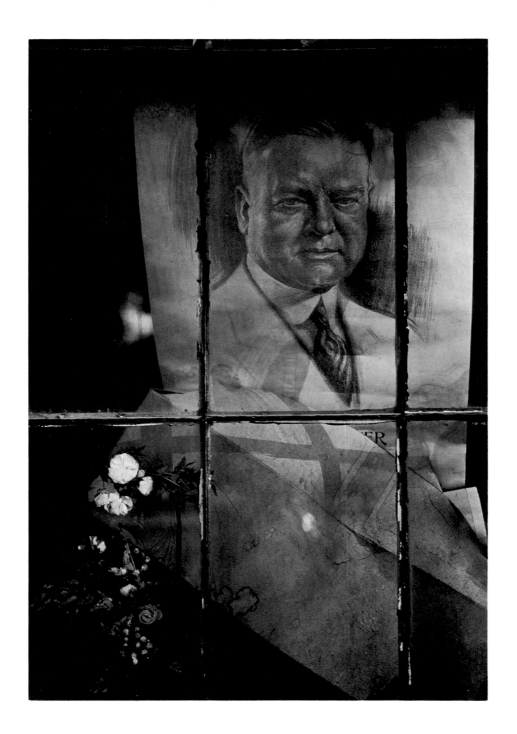

Truro, Massachusetts, 1931

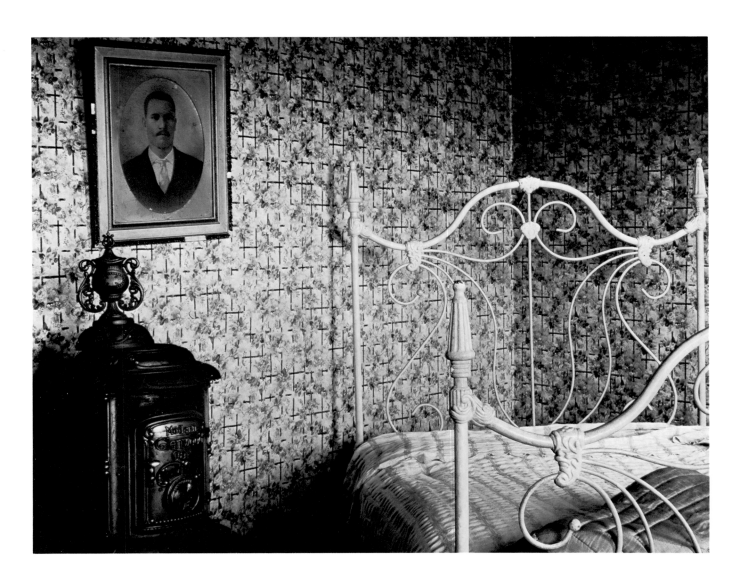

Scarborough, New York, 1931

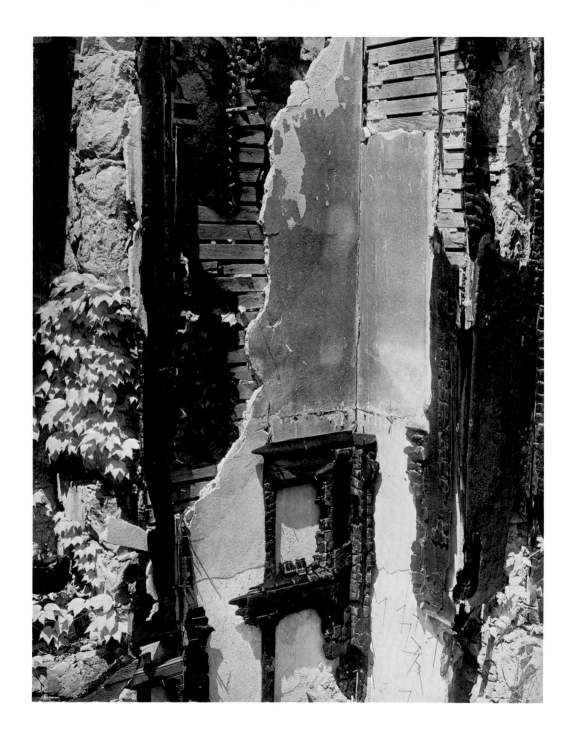

45

Maine Pump, 1933

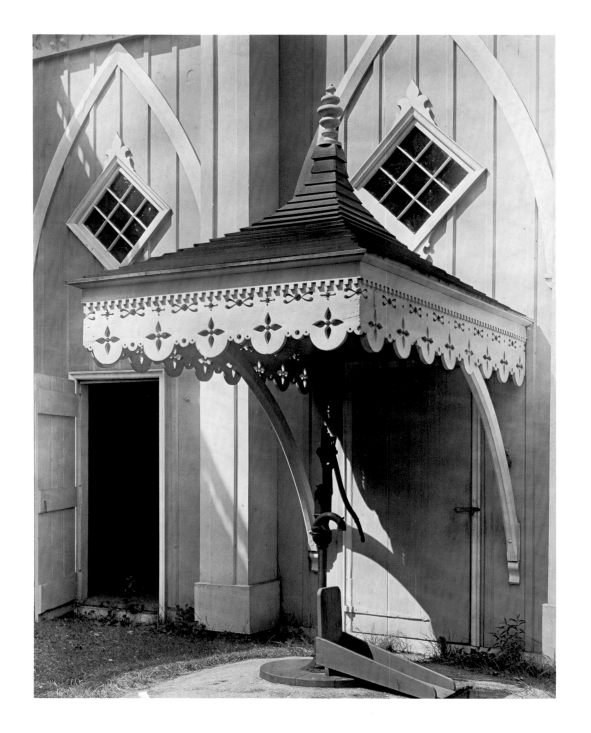

Portraits, New York City, 1931

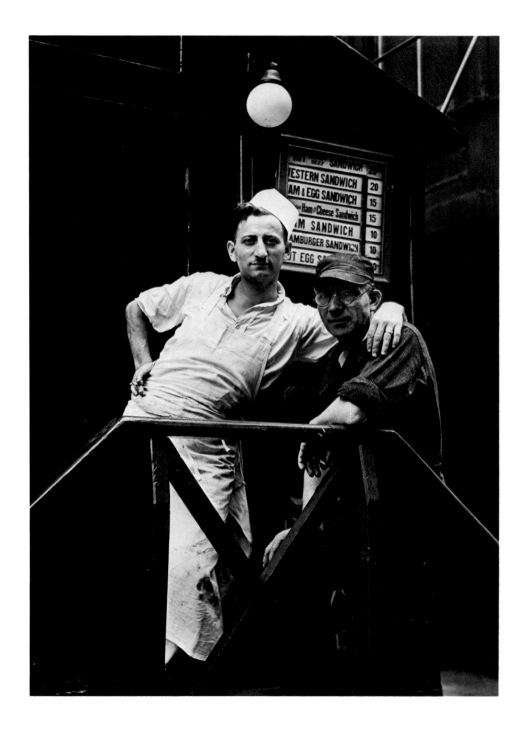

49

Minstrel Showbill, Alabama, 1936

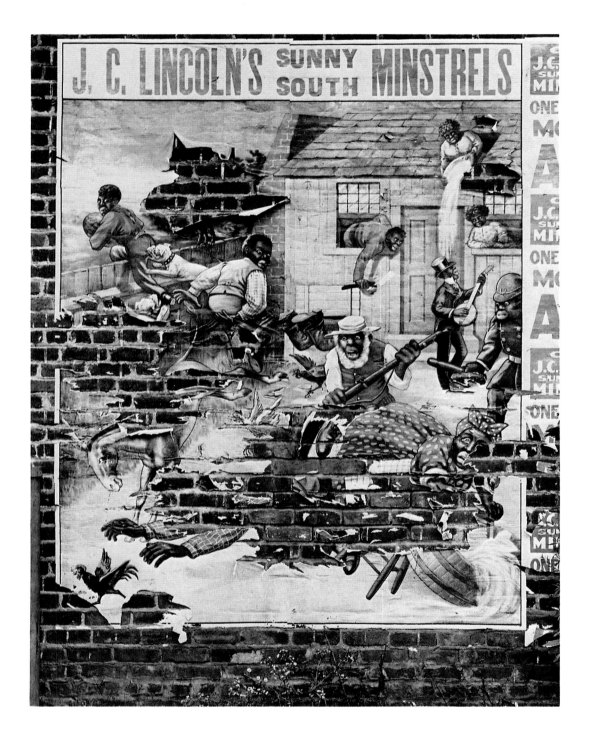

51

Floyd Burroughs, Hale County, Alabama, 1936

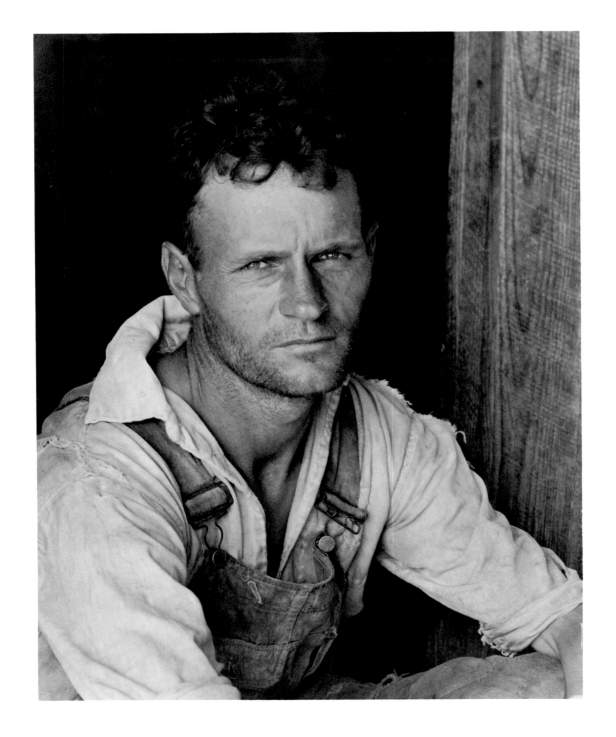

Allie May Burroughs, Hale County, Alabama, 1936

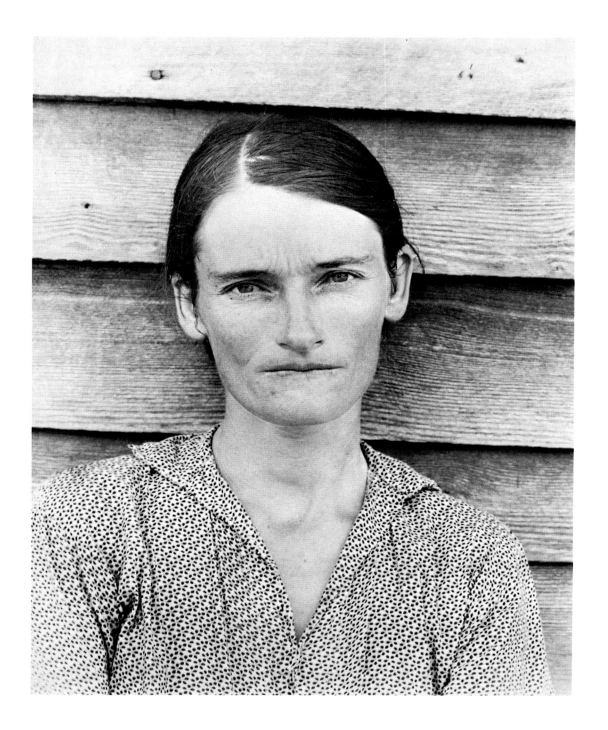

Mississippi, 1936

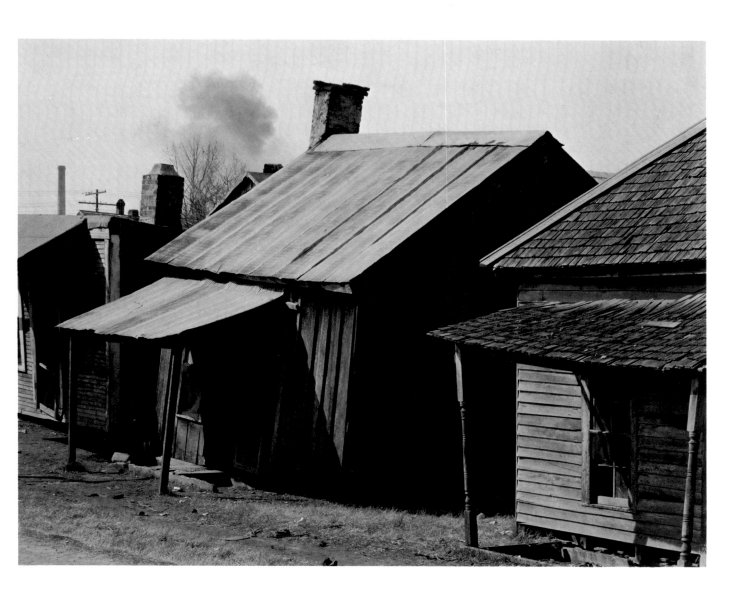

Bud Fields and His Family, Hale County, Alabama, 1936

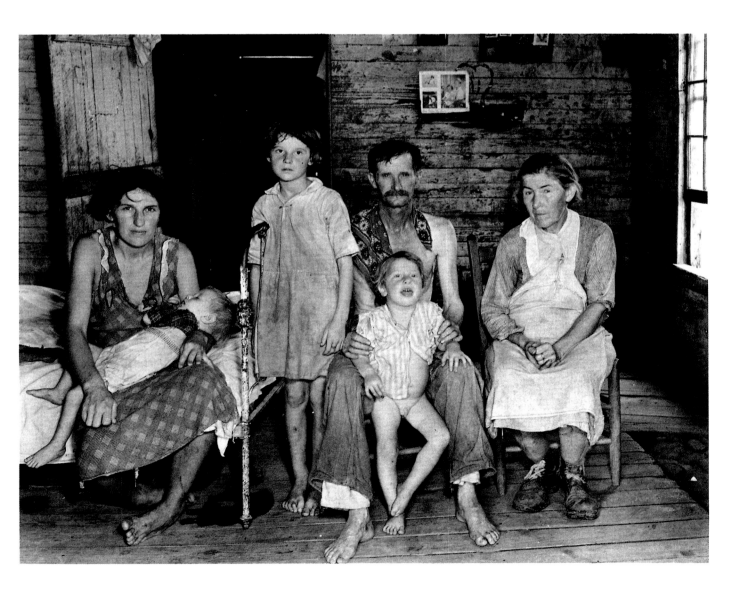

Burroughs' Kitchen, Hale County, Alabama, 1936

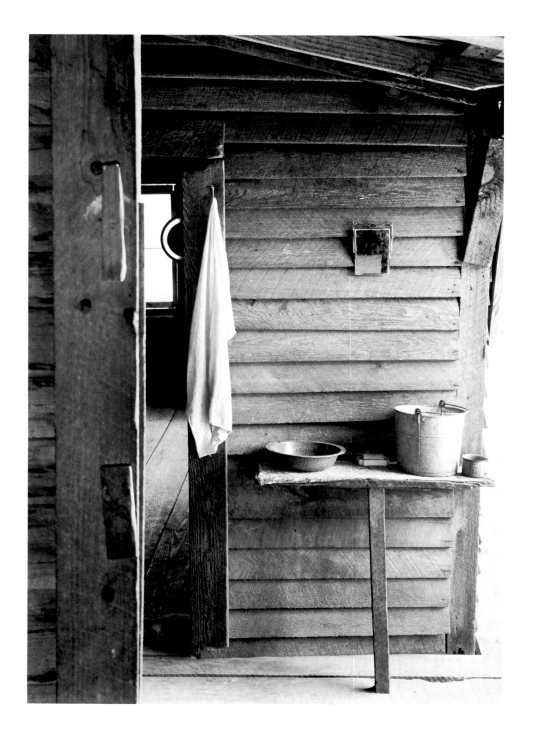

Kitchen Wall in Bud Fields' Home, Hale County, Alabama, 1936

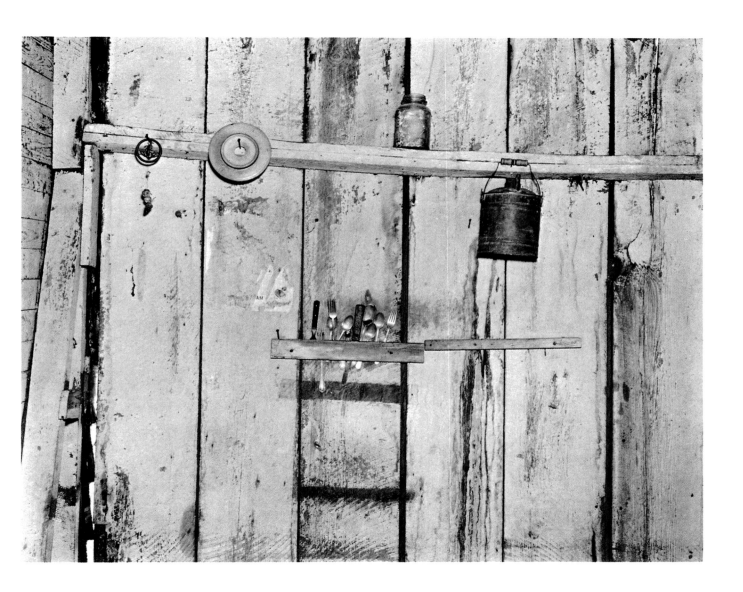

63

Country Church, South Carolina, 1936

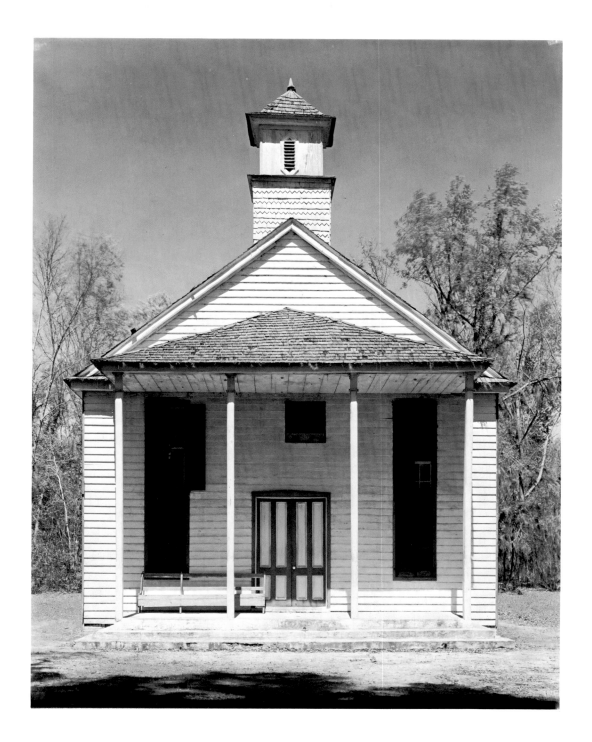

Country Church, South Carolina, 1936

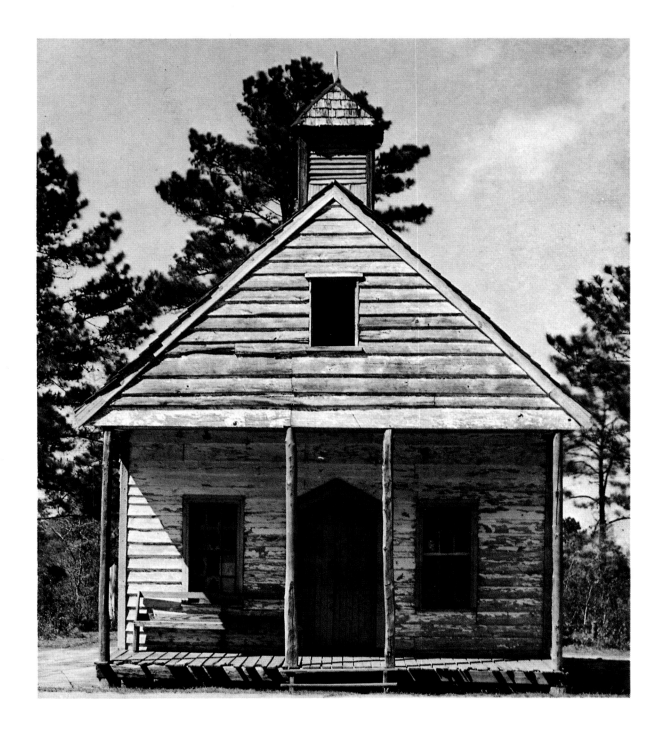

67

Church Interior, Alabama, 1936

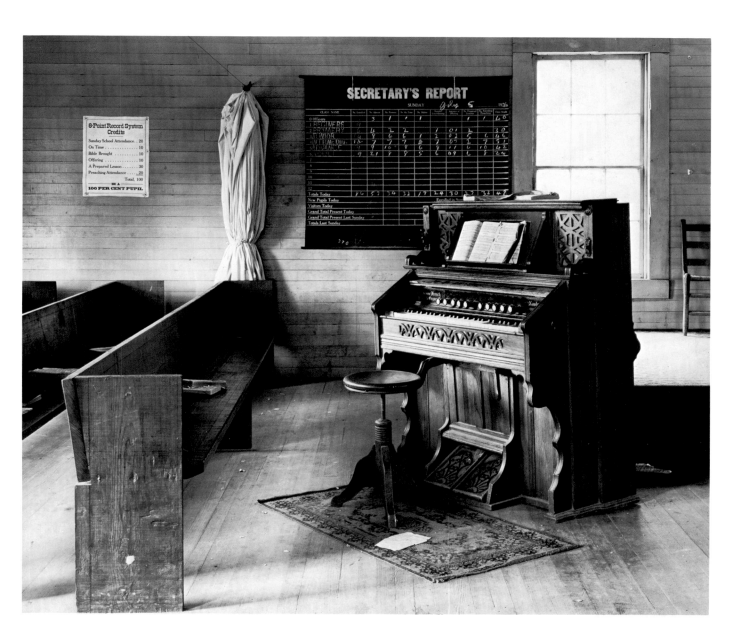

Moundville, Alabama, 1936

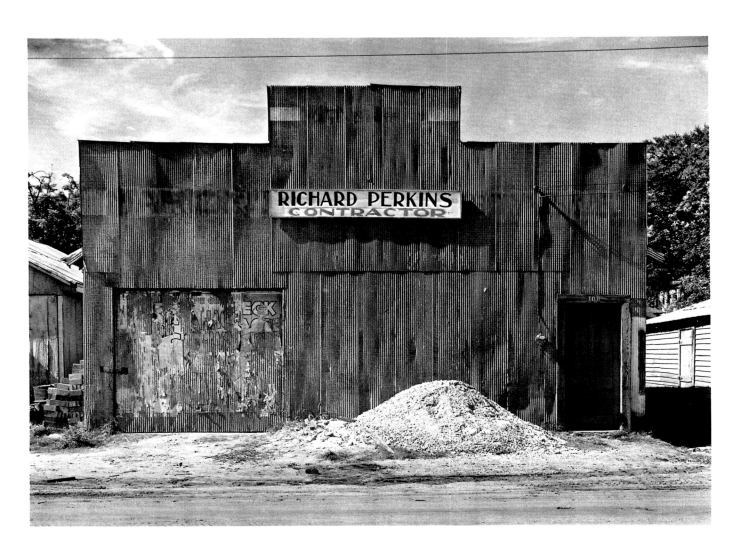

Roadside Store Between Tuscaloosa and Greensboro, Alabama, 1936

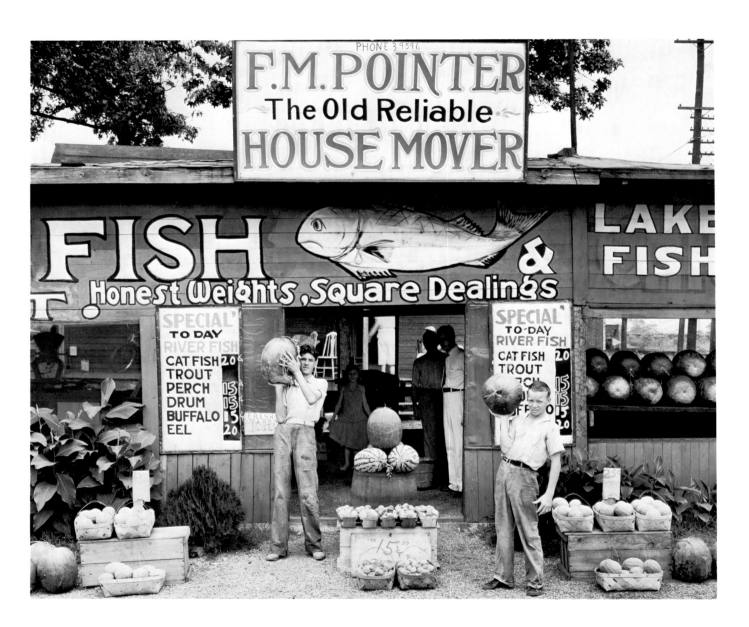

Company town, Alabama, 1936

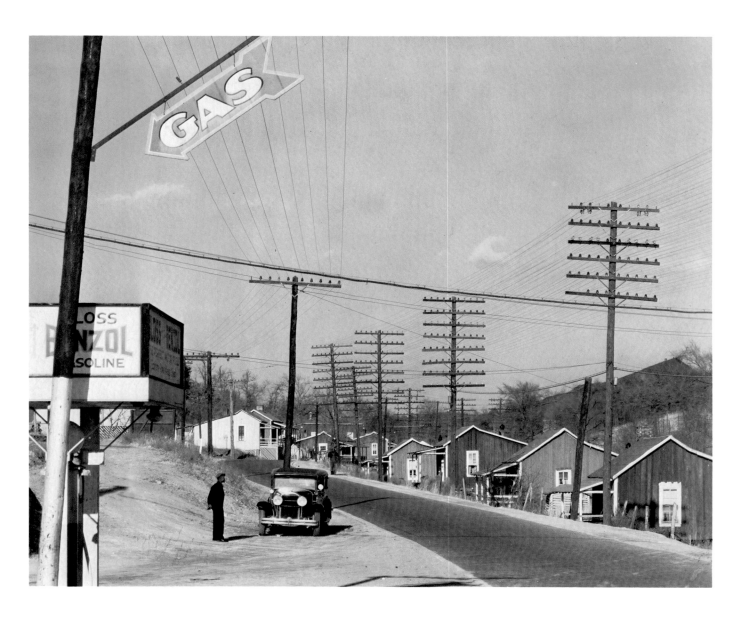

Coal Miner's House, West Virginia, 1935

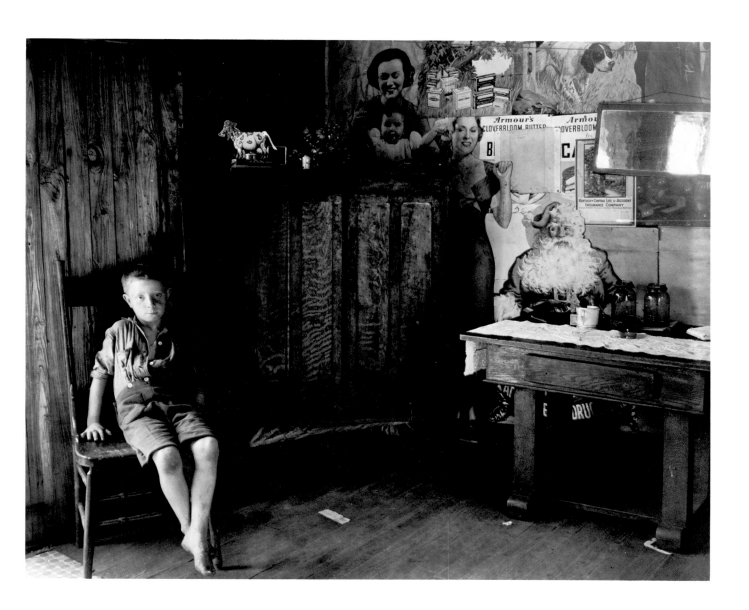

Coal Miner's House, Scotts Run, West Virginia, 1935

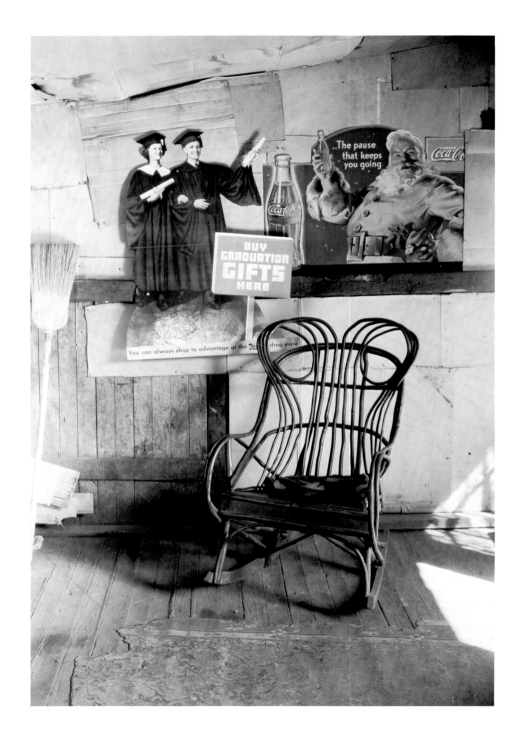

Phillipsburg, New Jersey, 1936

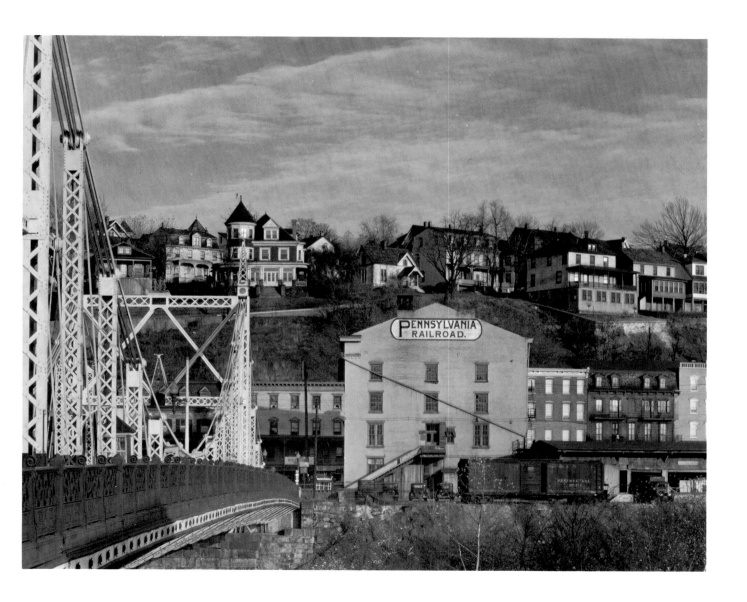

Atlanta, Georgia, 1936

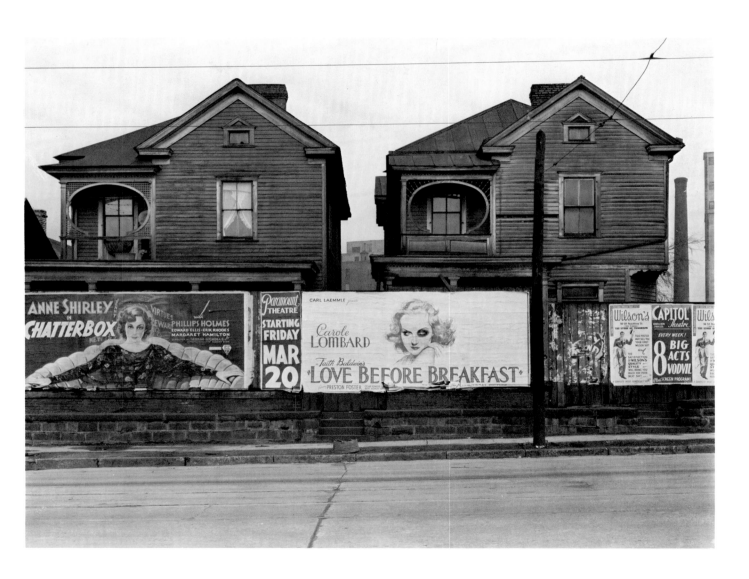

New Orleans, 1935

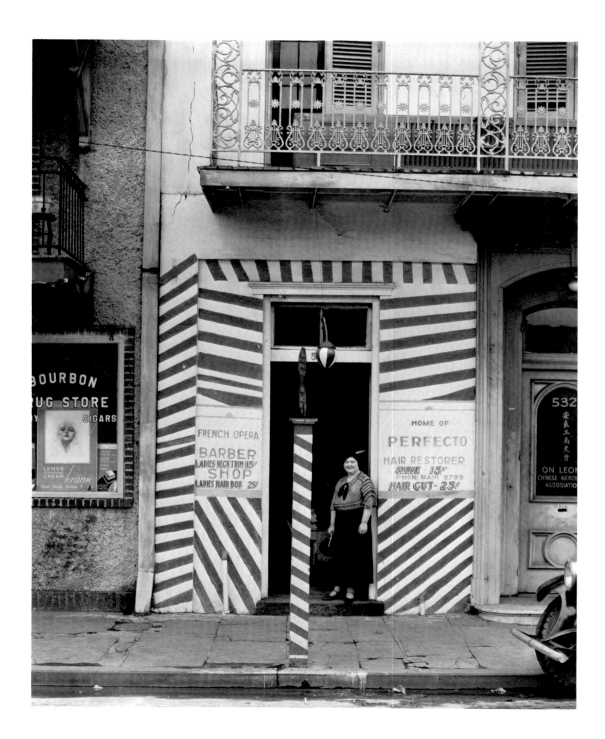

85

Tabby (shell) Wall, St. Mary's Georgia, 1936

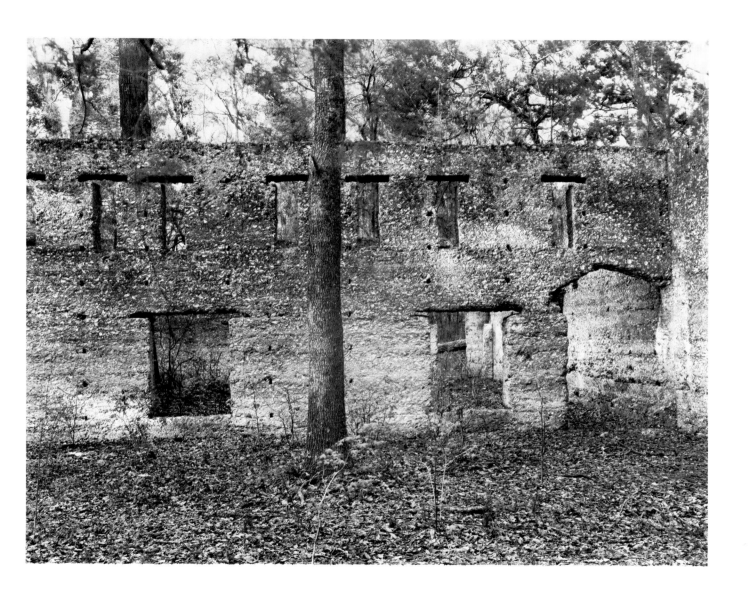

Studio Portraits, Birmingham, Alabama, 1936

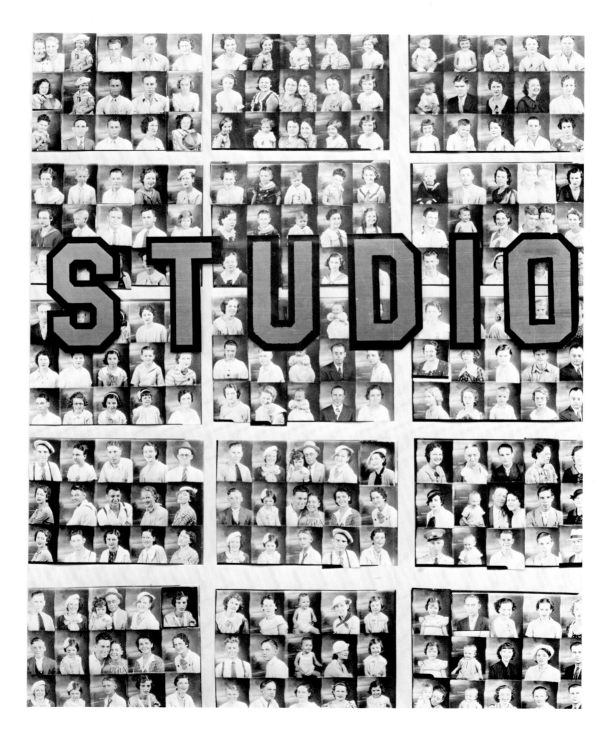

Chicago, 1947

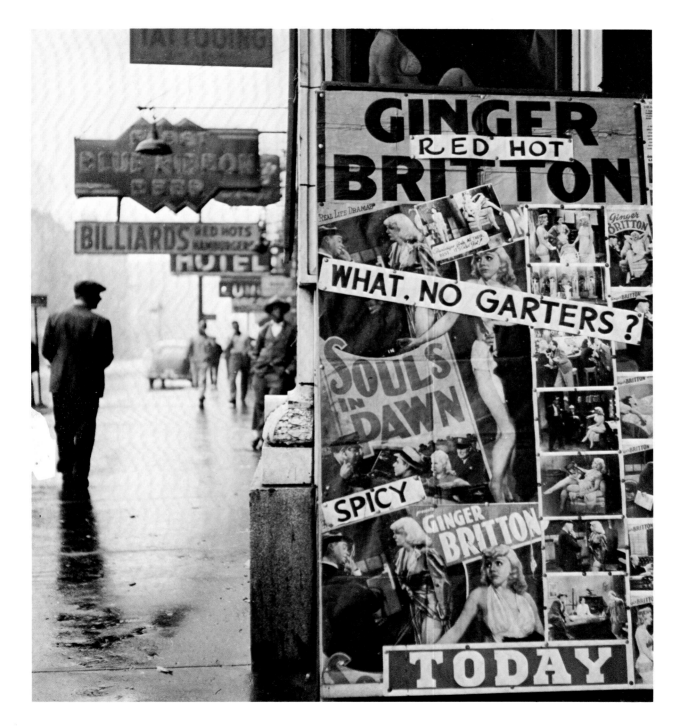

CHRONOLOGY

1903 Born 3 November, in Saint Louis, Missouri; lives as a youth in Toledo, Chicago, and New York City.

1922 Graduates from Phillips Academy, Andover, Massachusetts.

1922–26 Attends Williams College for a year, then works at odd jobs in New York City.

1923–25 Works in the Public Library, New York City.

1926–27 Resident in Paris; audits classes at the Sorbonne.

1928 Lives and works in New York, developing his experiments with photography into a serious commitment.

1930 Hart Crane's *The Bridge* published with illustrations by Evans; photographs by Evans published in Lincoln Kirstein's magazine *Hound & Horn*.

1931 Photographs Victorian architecture of Boston in association with Lincoln Kirstein. Included in first exhibition, John Becker Gallery, New York, with Ralph Steiner and Margaret Bourke-White.

1932 First one-person exhibition at the Julian Levy Gallery, New York.

1933 Carleton Beals's *The Crime of Cuba* published with illustrations by Evans.

1934 Photographs African sculpture on commission by the Museum of Modern Art.

1935–37 Works on the photographic survey of the Farm Security Administration.

1936 On leave from the FSA, photographs Southern tenant farmers in association with James Agee.

1938 *American Photographs* published, accompanying a major exhibition of Evans's work at the Museum of Modern Art; expands efforts in candid photography; begins portraits of New York subway riders.

1940 Receives first Guggenheim Fellowship.

1941 Receives second Guggenheim Fellowship; *Let Us Now Praise Famous Men* published.

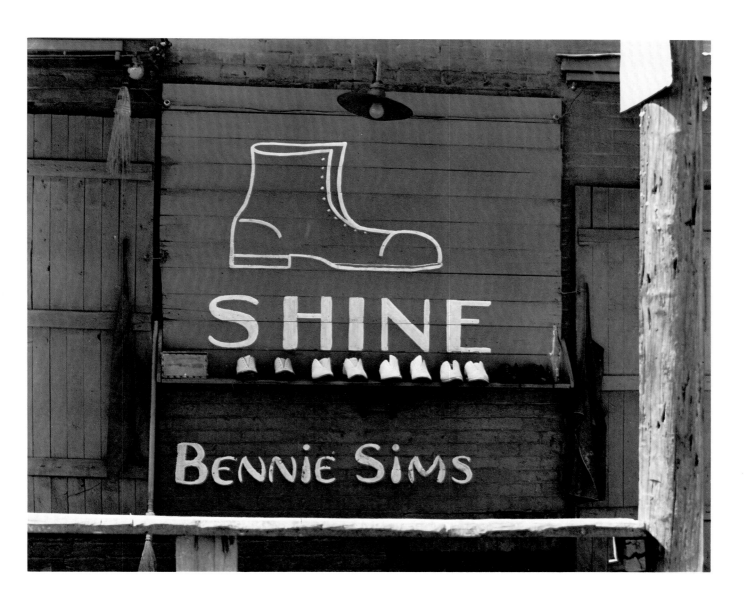

93

1942 Karl Bickel's *The Mangrove Coast* published with illustrations by Evans.

1943–45 As contributing editor at *Time* magazine, writes book reviews.

1945 Moves to *Fortune* magazine as staff photographer; later named associate editor.

1959 Receives third Guggenheim Fellowship.

1960 Marries Isabelle Boeschenstein; *Let Us Now Praise Famous Men* reissued.

1962 *American Photographs* reissued, accompanying an exhibition at the Museum of Modern Art.

1965 Retired from professional photography. Appointed Professor of Graphic Design, Yale University.

1966 *Message from the Interior* and *Many Are Called* published.

1968 Receives honorary degree from Williams College.

1971 The monograph *Walker Evans* published, accompanying a major retrospective at the Museum of Modern Art.

1974 Named Emeritus Professor at Yale University, New Haven.

1975 Dies 10 April in New Haven, Connecticut.

SELECTED BIBLIOGRAPHY

Books by Walker Evans

Agee, James and Evans, Walker. *Let Us Now Praise Famous Men: Three Tenant Families.* Boston: Houghton Mifflin, 1941. Thirty-one photographs by Evans. Reissued in 1960 with sixty-two photographs and a new foreword by Evans.

Beals, Carleton. *The Crime of Cuba.* Philadelphia and London: J. B. Lippincott, 1933. Thirty-one photographs by Evans.

Bickel, Karl. *The Mangrove Coast.* New York: Coward-McCann, 1942. Thirty-two photographs by Evans.

Crane, Hart. *The Bridge.* Paris: Black Sun Press, 1930. Three photographs by Evans.

Evans, Walker. *American Photographs.* New York: Museum of Modern Art, 1938. Essay by Lincoln Kirstein; eighty-seven photographs by Evans. Reissued in 1962 with a new foreword by Monroe Wheeler.

——. *Many Are Called.* Boston: Houghton Mifflin, 1966. Essay by James Agee; eighty-nine photographs by Evans.

——. *Message from the Interior.* New York: Eakins Press, 1966. Essay by John Szarkowski; twelve photographs by Evans.

——. *Walker Evans.* New York, Museum of Modern Art, 1971. Introduction by John Szarkowski; ninety-nine photographs by Evans.

——. *Walker Evans: First and Last.* New York: Harper & Row, 1978. Two hundred and nineteen photographs by Evans.

——. *Walker Evans: Photographs for the Farm Security Administration, 1935–1938.* New York: Da Capo Press, 1973. Introduction by Jerold C. Maddox; 551 photographs by Evans.

Sweeney, J. J. *African Negro Art.* New York: 1935.

Books and articles about Walker Evans

Baier, Lesley. *Walker Evans at Fortune 1945–65.* Wellesley, Massachusetts: Wellesley College Museum, 1977. Exhibition catalog notes and essay by Lesley Baier; thirty-one photographs by Evans.

Bunnell, Peter C. "An Introduction to Evans's Work and His Recollections." *Exposure,* New York (February 1977).

Deren Coke, Van. "Notes on Walker Evans and W. Eugene Smith." *Art International,* Lugano, Switzerland (June 1971).

Doty, Robert, ed. *Photography in America.* Introduction by Minor White. New York and London, 1974.

Herbst, Josephine. "Walker Evans: American Photographs." *Arts Magazine,* New York (November 1962).

Katz, Leslie, ed. "Interview with Walker Evans." *Art in America,* (March 1971). Eight photographs by Evans.

Kearns, Jerry and Bellamy, Leroy, comps., Hial Almakjian, ed. *The Years of Bitterness and Pride; FSA Photographs 1935–43.* New York, 1975.

Maingois, M. "Walker Evans." *Zoom,* Paris (April 1981).

O'Neal, Hank. *A Vision Shared: A Classic Portrait of America and Its People 1935–43.* New York and London: St. Martin, 1976.

Stot, William. *Documentary Expression and Thirties America.* Univ. of Chicago Press, 1973.

Travis, David. *America Observed: Etchings by Edward Hopper, Photographs by Walker Evans.* San Francisco, 1976. Exhibition catalog.

Yellin, Carol Lynn. *Images of the South: Visits with Eudora Welty and Walker Evans.* Memphis, Tennessee: center for Southern Folklore, 1977.

SELECTED ONE-PERSON EXHIBITIONS

1931 *Photographs by 3 Americans*, John Becker Gallery, New York (with Ralph Steiner and Margaret Bourke-White)

1932 *Walker Evans and George Platt Lynes*, Julien Levy Gallery, New York

1933 *Walker Evans: Photographs of Nineteenth Century Houses*, Museum of Modern Art, New York

1935 *Documentary and Anti-Graphic* (with Henri Cartier-Bresson and Manuel Alvarez Bravo). Julien Levy Gallery, New York

1938 *Walker Evans: American Photographs*, Museum of Modern Art, New York (toured the United States and Canada)

1948 Art Institute of Chicago

1962 *Walker Evans: American Photographs*, Museum of Modern Art, New York (toured the United States and Canada)

1964 Art Institute of Chicago

1966 *Walker Evans' Subway*, Museum of Modern Art, New York
Robert Schoelkopf Gallery, New York
National Gallery of Canada, Ottawa (toured Canada)

1970 *Walker Evans: Paintings and Photographs*, Century Association, New York

1971 Robert Schoelkopf Gallery, New York
Museum of Modern Art, New York (retrospective)

1972 Yale University, New Haven, Connecticut

1973 Robert Schoelkopf Gallery, New York

1974 Robert Schoelkopf Gallery, New York

1975 Kluuvin Galleria, Helsinki

1976 Bibliothèque Royale, Brussels
Museum of Modern Art, New York (toured the United States and Europe)
America Observed: Etchings by Edward Hopper, Photographs by Walker Evans, California Palace of the Legion of Honor, San Francisco (also shown at Acherbach Foundation for Fine Art, San Francisco)

1977 Cronin Gallery, Houston
Robert Schoelkopf Gallery, New York

1978 Sidney Janis Gallery, New York
Walker Evans at Fortune 1945–1965, Wellesley College, Massachusetts

1981 Milwaukee Art Center (with Ralph Steiner)
Walker Evans: 250 Photographies, Galerie Baudoin LeBon, Paris
Walker Evans and Robert Frank: An Essay on Influence, Fraenkel Gallery, San Francisco
Photographs of Chicago by Walker Evans, Kelmscott Gallery, Chicago

Aperture Masters of Photography series

"The Aperture Masters of Photography series is devoted to those individuals whose achievements have accorded them a place of vital importance in the history of the art form."—PSA Journal

Aperture's newly expanded Masters of Photography series presents an engrossing introduction to the photographers whose work has incalculably affected the way we regard the world. Each book in this series, now a total of eighteen volumes, presents more than forty major works spanning each artist's career, together with brief chronologies of the artist's life and exhibition history, plus a listing of public collections and major holdings of the work, and a selected bibliography. Each volume begins with an essay by a leading critic or historian, offering an incisive look at the photographer's career and importance in the history of photography.

to order call 1-800-929-2323 ext. 418

Essayists include: Dorothy Norman on Alfred Stieglitz, Mark Haworth-Booth on Paul Strand, A. D. Coleman on Manuel Alvarez Bravo, Jim Hughes on W. Eugene Smith, Jonathan Williams on Harry Callahan, and Margaret Hooks on Tina Modotti.

Each hardcover, clothbound volume features approximately forty duotone images.

8 x 8 inches; 96 pages, $12.50

Six new additions to the series are now available as a slipcased collector's set at a special price of $65.00. ISBN: 0-89381-837-2

Twelve-copy prepack available as a slipcased collector's set at a special price of $99.95. ISBN: 0-89381-818-6

12-copy prepack	**0-89381-818-6**
Berenice Abbott	0-89381-751-1
Manuel Álvarez Bravo	0-89381-742-2
Eugène Atget	0-89381-750-3
Henri Cartier-Bresson	0-89381-744-9
Walker Evans	0-89381-741-4
André Kertész	0-89381-740-6
Man Ray	0-89381-743-0
August Sander	0-89381-748-1
Alfred Stieglitz	0-89381-745-7
Paul Strand	0-89381-746-5
Weegee	0-89381-749-X
Edward Weston	0-89381-747-3
6-copy prepack	**0-89381-837-2**
Wynn Bullock	0-89381-827-5
Harry Callahan	0-89381-821-6
Eikoh Hosoe	0-89381-824-0
Tina Modotti	0-89381-823-2
Barbara Morgan	0-89381-825-9
W. Eugene Smith	0-89381-836-4

BEST WISHES,
AMEN

BEST WISHES, AMEN

A New Collection of Autograph Verses

Compiled by LILLIAN MORRISON

illustrated by Loretta Lustig

THOMAS Y. CROWELL COMPANY · NEW YORK

"Adam and his" (p. 3), "Plow deep" (p. 144), "Sometimes a
tie" (p. 76) copyright © 1962, reprinted from *Southern Folklore
Quarterly*, vol. 26, pp. 127–130, with permission of Alan Dundes
and *Southern Folklore Quarterly*. "I'm not much" (p. 5), "When
you get married" (p. 109), "Roses are red" (p. 120), "When you
fall down" (p. 155) reprinted from *Utah Humanities Review*, vol. 1,
pp. 245–260, copyright 1947 by the *Western Humanities Review*,
University of Utah, with their permission.

Every reasonable effort has been made to to
reprint those items already in copyright. If no the
editor and publisher will correct future editions.
L. C. Card 74–2456 ISBN 0–690–00579–2

1 2 3 4 5 6 7 8 9 10

Compiled by Lillian Morrison

BLACK WITHIN AND RED WITHOUT
A DILLER, A DOLLAR: RHYMES AND SAYINGS FOR THE TEN O'CLOCK SCHOLAR
REMEMBER ME WHEN THIS YOU SEE
SPRINTS AND DISTANCES: SPORTS IN POETRY AND THE POETRY IN SPORT
TOUCH BLUE
YOURS TILL NIAGARA FALLS

By Jean Boudin and Lillian Morrison

MIRANDA'S MUSIC

Contents

Preface

They're still doing it. The custom among American children of writing sayings and verse for memory's sake in each other's autograph albums goes on. Year after year, in spite of television, space travel, computers, and other technological marvels which have changed our lives, out come the albums at graduation time (or at summer camp) in big cities and in small country towns.

There is something satisfying about this persistence. And it is children we must thank for so many of the humanly appealing traditions which do survive in these times of future shock. In their own way, they often preserve what yesterday's adult world has discarded. "Ring Around the Rosey," the children's game, has been traced to prehistoric pagan rituals, to name one example. Writing in autograph albums is

not that ancient, but the custom did begin as far back as the mid-sixteenth century among university students in Europe who carried a leatherbound book known as an *album amicorum* in which would be inscribed Latin quotations, literary excerpts, recommendations, and good wishes by friends and patrons.

In this country, the albums began to be popular in the early nineteenth century and became more and more so, until in the eighteen-seventies and eighties they were a fad. Albums in various shapes and sizes, often lavishly adorned with floral decorations, were brought out and passed around at parties of young people usually in their late teens and twenties. The verses inscribed tended to be sentimental effusions or homely aphorisms, often original rather than quoted, or taken from printed collections of album verse such as *The Album Writer's Friend,* popular at the turn of the century. The handwriting was ornate Spencerian, with the more talented inscribers showing off their flourishes and calligraphic drawings.

Now, in our own day, the album entries, reflecting as they do the changes in our folkways, are much more down-to-earth, cynical, humorous, and the people who write them are younger (usually fifth through ninth grade). The handwriting is often terrible. The verses

are a hodgepodge of the sentimental and the mocking, the nostalgic and the impudent. They contain awful puns, insults, moral advice, complaints, and compliments, and they deal, if ever so lightly, with basic subjects—love, marriage, personality, school, success. They are cousins to or descendants of "knock book" entries, valentines, didactic primer rhymes, street taunts, snatches of folk song. The supply seems to be endless. I have had fun collecting them for years, and two earlier books *Yours Till Niagara Falls* (1950) and *Remember Me When This You See,* (1961), have resulted from these cullings.

In looking at today's albums for this my third published collection, I was interested in what changes I might find. There was the usual mixture of the old and the new. Along with many verses that might have been found in mother's or grandmother's album were fresh pieces or modifications of older rhymes reflecting pollution, long hair, and women's liberation. In several New York City albums, one could see the influence of subway graffiti in the way some writers signed their names—an ornate signature in block letters with a street number after it, e.g., Debbie 200. Also with the great influx in recent years of Spanish-speaking people, especially Puerto Ricans, into New York City where most of my collecting is done, I came upon many more rhymes

in Spanish, some of them very closely corresponding to popular English ones.

To me these little books and their verses continue to be sources of great pleasure as well as signs of change and continuity. They are true Americana, expressing the rhythm, wit, warmth, originality, and irrepressible vitality of the young.

This Is
Page One

This is Page One
And just for fun
I'll begin the text
By putting my "x."

Adam and his better half
Never had an "autograph."

I know that I'm a runt
So I'm going to make this blunt.
Good Luck.

3

WORDS
WORDS
WORDS
WORDS

I said it,
I meant it,
I'm here to represent it.
I'm a cool calm soul fool
From the fly town.

I'm not much for lines,
I'm not much for thought,
But here's wishing you
All the good luck wished to you
In this book that you bought.

 CU want

m

N H T P O M Y
(Never had the pleasure of meeting you)

I don't know who tells me
But I sure know what to say.

I'm the monster of Loch Ness.
My name you'll never guess.

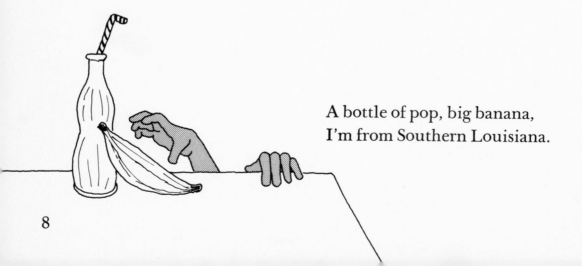

A bottle of pop, big banana,
I'm from Southern Louisiana.

8

I'm Cliff.
Drop over sometime.

My name's Jimmy.
I'll take all you'll gimme.

I dip my pen into the ink
And grasp your album tight
And for your sake I cannot think
A single word to write.

I've tried to think of something
But my mind has fallen flat.
I'll say that you're a friend of mine
And let it go at that.

Ministers sign their names to texts,
Businessmen sign their names to checks,
Fools sign theirs to make you laugh
But here goes mine for an autograph.

llllllllllll lllll llll
lllll lllll lllll lllll lll
llllll llllllll llll

Until I learn to write, this is all I have to say.

Rich men spoil the city
Poor men spoil the town
And I'm going to spoil your album
By writing upside down.

Roses are red, green grow the hedges, I hope you dont mind me writing on the edges.

for a white page

If this page were a pretty pink
I'd have to say I think you stink.
But since I picked one white as a dove.
I'll gladly say you're one I love.

On this page of pearly white
It looked so good I took a bite.

for a blue page

On this page of pinky pink
I sign my name in pen and ink.
May your fondest wish come true,
Oh, my gosh, this page is blue.

On this page of bluey blue
I will take a little chew.

for a green page

Green is the color I like best.
Jeanne is the girl I wish success.

I've signed my name on this green page
For you to read in your old age.

You think you're smart,
You think you're fine,
But I'll bet you can't sign
Your name under mine.

Barry Jackson

To be written after someone who has written:
 By hook or by crook
 I'll be last in your book.

 By eggs or by bacon
 You're sadly mistaken
 or
 Not so, my friend.
 I'm at the end.

Sitting in the Schoolroom

Roses are red,
Violets are blue.
St. Joseph's is glad
To get rid of you.

Roses are red,
Violets are blue.
Let's hope the teachers
Keep passing you.

Roses are red,
Violets are blue.
How the heck
Did you get through?

Over the ocean,
Tomorrow's promotion.

Abracadabra
Who is that jabberer?

Cleopatra ruled the Nile,
Harvey's briefcase rules the aisle.

Hit 'em in the head,
Hit 'em in the feet,
Class 8–7
Can't be beat.

Confucius say:
 All pupils of P.S. 156 go to Heaven.
 They already been through Hell.

Roses are red,
Coal is black.
How I will laugh
When you get left back.

Good guys, bad guys,
Cops and robbers,
Let's join hands
And boycott barbers.

While P.S. 2 is getting a rest,
P.S. 5 is getting a pest.

Deck the halls with poison ivy.

Friends, Romans, classmates,
Lend me your homework.

God made the teachers in the night
And forgot to make them bright.

I'm not a genius,
I'm not a fool,
I'm just a boy
Who goes to school.

Remember the bottle,
Remember the glass,
Remember the fun
In Erdleman's class.

I wasn't late, the bell was early.

Remember the school,
Remember the slum,
Remember the way
We chewed our gum.

Sitting in the schoolroom
Chewing bubble gum,
In comes the principal
And out goes the gum.

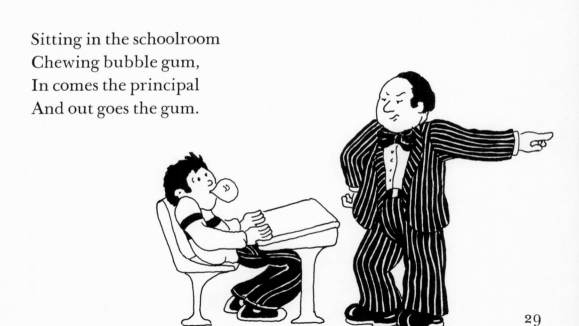

29

Remember the pen,
Remember the book,
Remember the day
You played the hook.

Remember the row,
Remember the seat,
Remember the way
You used to cheat.

Up the river,
Down the lake,
Teacher's got
The bellyache.

Work never killed anyone—
but I'm not taking a chance.

Over the hill there is a school
And in that school there is a room
And in that room there is a stool
And on that stool there is a fool
And the fool is Jacky Muller.

Vacation, vacation,
Soon we'll be standing at the Greyhound bus station.

City of Love,
State of Wishes

City of Love
State of Wishes
19 Hugs
74 Kisses

Roses are red,
Violets are green.
I think you're in love
With Mr. Clean.

Roses are red,
Lilies are white.
I love you, Joey
Morning, noon, and night.

If the ocean was milk
And the bottom was cream,
I'd dive for you
Like a submarine.

I love you in blue,
I love you in red,
But best of all
I love you in yellow.

I love you on the hillside,
I love you on the level,
But when you're in my arms
I love you like the devil.

As deep as the deep blue sea,
As pure as the pearls of the ocean,
So deep is my love for you,
So pure is my heart's devotion.

Don't make love in an onion patch.
Onions repeat.

I love you once,
I love you twice,
I love you next to beans and rice.

Do you love me
Or do you not?
You told me once
But I forgot.

East is East
West is West.
You're the one
That I love best.

39

If you think you are in love
And still there is some question,
Don't worry much about it,
It may be indigestion.

Dewey was an admiral down on Manila Bay,
Dewy were the morning skies in the lovely month of May,
Dewy were her eyes when she said "I love you true."
Oh, do we love each other? I should say we do.

If you could look into my heart
And see the love that's there,
Then turn it into money,
You'd be a millionaire.

If ever I go to Paradise
And do not see your face,
I'll pick up all my valuables
And go to the other place.

The girl of my choice
Must be free from disguise,
Show her heart in her face
And her soul in her eyes.

Green is green,
Yellow is yellow.
How many times
Did you kiss that fellow?

Health and happiness,
Peace and good will.
I always loved kissing
And so I do still.

Here I stand on two little chips.
Come and kiss my two little lips.

I wish I were a graham cracker,
I wish you were one too,
Then we could get into a glass of milk
And I could mush with you.

45

H O L L A N D
o u o a n e i
p r v s d v e
e e t e s
 s r

46

I don't want any money
If you will be my honey.

I love cookies,
I love pie,
I will love you
Till I die.

Debbie and Mark

$$\begin{array}{r} 2 \text{ people} \\ 2 \text{ gether} \\ \hline 4 \text{ ever} \end{array}$$

Here I stand all nice and clean.
If the boys don't kiss me
I think they're mean.

Tis sweet to kiss
But oh how bitter
To kiss the lips
Of a tobacco spitter.

There is many a kiss to remember,
There is many a kiss to forget,
But the kiss you would like to remember
Is the kiss that you want and don't get.

Romeo made love to Juliet,
Punch made love to Judy,
But the funniest thing I ever did see
Was Katy making love to a cootie.

Mountains may rise,
Mountains may fall,
But my love for you
Will live through it all.

I wish you were a little mouse
And I a cat. How I would watch you!
I'd chase you all around the house,
You little mischief, till I'd catch you.

May you kiss whom you please
And please whom you kiss.

Love and a cough cannot be hid.

I've Seen
Prettier Girls

Anne stood on the balcony,
A rose in her teeth.
She threw him the rose.
He threw back her teeth.

I'm a cute little girl
With a cute little figure,
But step back, boys,
Till I get a little bigger.

Just because your head is shaped like an air conditioner
doesn't mean you're so cool.

God made the rivers,
God made the lakes,
God made you.
We all make mistakes.

Bread and butter,
Sugar and spice,
Lots of boys
Think you're nice.

If Richard were King
God save the Queen.

I love to go fishing,
I love to catch trout,
I'd love to meet the guy
Who can shut Betty's mouth.

Grow up, grow up.
Every time I look at you
I throw up.

Your father is a baker,
Your mother cuts the bread,
And you're the little doughnut
With a hole in the middle of your head.

Did you ever stop to think
When you'd been to the zoo,
That the monkeys there
Had been looking at you?

Don't worry—the Liberty Bell is cracked too.

Snow White gave a party;
All the dwarfs were there,
All except Dopey.
Where were you, my dear?

Shame on You

Not because you're dirty,
Not because you're clean,
But because you kissed a girl
Behind the magazine.

Roses are red,
Violets are blue.
Umbrellas get lost.
Why don't you?

Roses are red,
Violets are blue.
What you need
Is a good shampoo.

Roses are red,
Violets are green.
You have a shape
Like a washing machine.

Roses are red,
Violets are blue.
I love me
And you love you.

Roses are red,
Violets are green.
Take my advice
And use Listerine.

Roses are red,
Washington's dead.
Barrels are empty
And so is your head.

2	skinny
2	go
4	fatties like me.

Henry's in the White House
Waiting to be elected;
Johnny's in the garbage can
Waiting to be collected.

Like London—always in a fog.

Just like a puzzle, always mixed up.

A mind like Webster,
A head like Clay.

The more I think of you
The less I think of you.

Oranges are oranges,
Peaches are peaches,
I've seen prettier girls
Lying on beaches.

Put your brains in a jaybird's head
and he'd fly backwards.

Roses on my shoulders,
Slippers on my feet,
I'm my mother's darling.
Don't you think I'm sweet?

To the prettiest girl in the world
From the biggest liar in the world.

2	good
2	be
2	soon
4	got
10	

There are rocks in the ocean,
There are rocks in the sea
But how the rocks got in your head
Is a puzzle to me.

When nothing is left to say
Lester says it.

Sweet is the girl who reads this line;
I wish her sweetness were all mine.

You are your mother's darling child
Brought up with care and trouble.
For fear a spoon would hurt your mouth
She fed you with a shovel.

You look like 500 miles of bad road.

You think you're cute
With a pickle for a snoot
In your 5-cent shirt
And your 10-cent suit.

Your house is so classy,
You've got rats as big as Lassie.

You used to be behind before
But now you're first at last.

Friendship
Is like China

You're a joy to behold
Even now that you're old
But admit it was fun
When we shared Grade One.

Friendship is like china
Costly and rare.
Tho' it can be mended
The scratches are always there.

Pal of my cradle days

Sometimes a tie is round your neck
And sometimes in a railroad track
But best the tie that makes us friends
When school-day memories come back.

A friend in need
Is a friend indeed.

Violets are blue,
Roses are red.
I'm your friend,
The tall redhead.

Although we argue
Curse and fight,
I like you
'Cause you're OUT-A-SIGHT.

A. F. A.
(A Friend Always)

There are three kinds of friends:
> best friends
> guest friends
> and pest friends.

> When folks like you are far away
> We think a lot about them
> And find it harder every day
> To get along without them.

79

Way up on the hill
There lives a fine gal.
Her name it is Jean
And she'll do for a pal.

When months and years have glided by
And on this page you cast your eye
Remember it was a friend sincere
That signed her name on this page here.

When on this page your eyes do bend
Think of me only as your friend.

You were my friend.
I hope I was yours.

Yours till Russia takes down the Iron Curtain
and puts up drapes.

Yours till the Iron Curtain rusts.

Yours till the cereal bowls.

Yours till the foot of Main Street
comes walking home.

Yours till day breaks.

Yours till a man-eater eats a woman.

Yours till lip sticks.

Yours till the pencil case is solved.

Yours till lemon drops.

Yours till Gaza strips.

Yours till ice skates.

Yours till Buffalo Bill
Comes over the hill.

Yours till Brussels sprouts.

Yours till potato chips, the ferry slips, and the comic strips.

Yours till my breath comes in pants.

Boys Are Humbugs

Boys are humbugs
All things show it.
I once thought so,
Now I know it.

Girls who chatter
Don't much matter.

You can tell a tree
By the fruit it bears
But you can't tell a boy
By the sneakers he wears.

Roses are red,
Stems are green.
Boys are sweet
But oh how mean.

Roses are red,
The sea is deep.
A young man's heart
Is hard to keep.

Butter is butter,
Cheese is cheese.
1974 women
Are hard to please.

Ashes to ashes,
Dust to dust.
These 1974 boys
We cannot trust.

Boys are mean,
Boys are vicious.
But ah their kisses
Are delicious.

Always be happy,
Always be gay,
Never get married
And you'll never get gray.

Donna, Donna,
Take my advice,
Don't be a mother
Before you're a wife.

If a fellow tries to win your ♥

Make sure he gives you many ♦

If he is untrue, hit him with a ♣

And let the undertaker use the ♠

My mother told me not to smoke.
Ha Ha I don't.
My mother told me not to drink.
Ha Ha I don't.
My mother told me not to kiss.
Ha Ha.

It takes a cool cool boy
From a cool cool town
To get a cool cool girl
And cool her down.

Fall from a steamer's burning deck,
Fall from a horse and break your neck,
Fall from the starry skies above,
But never, never fall in love.

When the dusk of twilight's falling
And a voice is saying low,
"Ginny, won't you please be mine?"
Be wise and answer, "No."

No matter what anyone says,
No matter what anyone thinks,
If you want to be happy the rest of your life
Don't marry a man if he drinks.

Don't try to be an angel
Looking on a star
But try to be the girl
Your mother thinks you are.

Gloria is your name,
Tremont is your station,
Better leave the boys alone
And get your education.

All the Girls
Are Marrying

The old sow whistles
And the little pigs dance.
All the girls are marrying
But I can't get a chance.

Sugar, sugar,
Salt, salt,
If you don't get married
It's not my fault.

Peaches in the parlor,
Apples on the shelf,
I'm getting tired
Of living by myself.

He took her in the garden
And set her on his knee
And said, "Baby, please,
Won't you marry me?"

Grass grows low
Oats grows tall
We'll get married
Some time next fall.

When you bake your first cherry pie
Don't give me any. Sorry,
I'm too young to die.

Over latch,
Under latch,
It takes good kisses
To make a match.

You are not very pretty.
It will be hard for you to get married.
I've written in this book
To hope you won't be tarried.

When you get married
And your husband is cross,
Come over to my house
And eat apple sauce.

Ducks on the mill pond,
Geese on the ocean,
Mary won't get married
Till Stevie takes a notion.

When you're courting
It's honey and pie
But when you get married
It's "root, hog, or die."

Roses are red,
Violets are blue.
I'd spell pneumonoultramerioscopicilicovalcanokonesser
Rather than marry you.

When you get married
And live on a hill,
Don't fall down
Like Jack and Jill.

Get the ladder
Get the rope
'Cause Sharon and Jimmy
Want to elope.

She who weddeth keeps God's letter.
She who weds *not,* doeth better.
Will you keep the sense of the Holy Letter
Content to do well, without doing better?

When you get married
And live in New York,
Don't open the door
It may be the stork.

When you get married
And drive a truck,
Order your children
From Sears and Roebuck.

Save your money
And buy a mule
To take your kids
To Sunday school.

May the sun shine East,
May the sun shine West,
May the sun shine best
On your little love nest.

$$x = \text{man}$$
$$y = \text{woman}$$
$$x + y = z$$
Solve for z.

When you get married
And live in a shanty
Please tell your children
To call me Aunty.

A ring is round
And so's a shilling.
When you're ready
I am willing.

When you get married
And live upstairs
Don't throw dishwater
On my chairs.

My head spins and my feet tingle
When I think that you're still single.

When you get married
And live in a flat
Don't get mad
And kill the cat.

When you get married
And have 8 or 9,
Bundle up yours
And come to see mine.

When you get married
And have 24,
Call it an army
And win the next war.

Lincoln, Lincoln, I've Been Thinkin'

Lincoln, Lincoln, I've been thinkin'
What's that stuff that you've been drinkin'?
Looks like water, tastes like wine.
Oh, my gosh, it's turpentine.

Roses are red,
Violets are blue.
I'm the mad Russian,
How do you do?

Roses are red,
Violets are blue.
Sugar is sweet
And good in your coffee.

Roses are red,
Violets are blue.
You vote for me
And I'll vote for you.

There once was a grizzly bear
Who had not a single care
Then one smoggy day
He went out to play
And died of polluted air.

Mary had a little lamb
Whose fleece was white as snow;
She took it down to Pittsburgh
And look at the darn thing now.

Roses are red,
Violets are blue.
Unless you have a garden
That won't affect you.

Coca-Cola came to town,
Pepsi-Cola shot him down,
Dr. Pepper fixed them up,
Now they all drink 7-Up.

The boy stood on the burning deck
Eating peanuts by the peck.
A girl stood by all dressed in blue
And said, "I guess I'll have some too."

The boy stood on the burning deck.
His feet were full of blisters.
He tore his pants on a rusty nail
And so he wore his sister's.

The boy stood on the railroad track.
The train was coming fast.
The boy stepped off the railroad track
And let the train go past.

Doctor Bell fell down the well
And broke his collar bone.
Doctors should attend the sick
And leave the well alone.

The higher the mountains
The cooler the breeze,
The higher the skirts
The cooler the knees.

Mary had a little lamb,
Its fleece was white as snow.
Mary passed a butcher shop
But the lamb went by too slow.

I saw you in the ocean
I saw you in the sea
I saw you in the bathtub
Oops, pardon me!

I went to your house for a piece of cheese.
A rat jumped up and said, "Gimme some, please."

In the dark, dark world
There's a dark, dark country.
In the dark, dark country
There's a dark, dark forest.
In the dark, dark forest
There's a dark, dark house.
In the dark, dark house
There's a man trying to find a fuse!

Ladies and gentlemen, I come before you to
stand behind you, to tell you something I know
nothing about. Next Thursday which is good Friday
there will be a meeting of the Ladies Club for
men only. Admission free, pay at the door, pull
up a chair and sit on the floor. The next meeting
will be held at the four corners of the round
table.

The night was dark, there was no moon,
The lightning flashed and killed a raccoon,
The rain came down with an awful thud
And said to the dust, "Your name is mud."

A millionaire's money has two taints,
'Taint yours and 'taint mine.

My mother was born in England,
My father was born in France,
And I was born in diapers
Because I had no pants.

One fine day in the middle of the night
Two dead men got up to fight.
One was a clown, and the other was a goon.
They fought all day that night till noon.

I went into the garden
To pick a pan of peas;
I almost died a-laughing
To hear a chipmunk sneeze.

There was once a young man named Paul
Who went to a fancy-dress ball.
He thought he would risk it
And go as a biscuit
But a dog ate him up in the hall.

Little Miss Muffet
Sat on a tuffet
Eating her curds and whey.
Along came a spider
And sat down beside her
And she picked up a spoon and beat the Hell out of it.

You can take a horse to water
But a pencil must be lead.

Turn to the next page and see a man
jump out the window

Too late. He jumped already.

I had a television set,
Put it up a tree,
Only channel I could get
Was WABC.

This is a free country
Free without a doubt.
If you haven't got a dinner
You're free to go without.

I've been eating onions.
Don't breathe it to a soul.

You think all pies are round
But πr^2.

Everything has an end and a piece of string has two.

Be Kind in All
You Say and Do

Be kind in all
You say and do
That others may
Be kind to you.

Money talks
Nobody walks.

Roses are red,
Violets are blue.
Please shut the door
When you go through.

He who takes what isn't his'n
Must give it back or go to prison.

The man who has plenty of good peanuts
And gives his neighbor none,
He shan't have any of my peanuts
When his peanuts are gone.

When a task is once begun
Never leave it till it's done.
Be it great or be it small
Do it well or not at all.

Say it.
Don't spray it.

It's nice to be natural
When you're naturally nice.

Though they scold and nag and argue
And their faults are not a few,
Though you at times may doubt it
Remember this is true:
All appearances to the contrary,
Mothers are people too.

When you're up to your neck in hot water
Be like a kettle and sing.

Hang on
Hang in
Hang loose.

top.
the
at
room
always
is
There

Plow deep while sluggards sleep
And you'll have corn to sell and keep.

If your shoe is in a knot
Patience will untie it.
Patience will do many things.
Did you ever try it?

When you grow up and have a car
Don't go too fast, don't go too far,
For if you do, you'll have a crash
And the insurance company will lose its cash.

Pity without relief
Is like mustard without beef.

Monkey see
Monkey do
Monkey get in trouble too.

The world will never adjust itself
To suit your whims to the letter.
Some things must go wrong your whole life long
And the sooner you know it the better.

Ladies and Gentlemen,
Take my advice.
Don't scratch your head
Unless you've got lice.

It's a long way to "Easy Street"
 and the buses aren't running.

In this world, you can do as you please
 if you please as you do.

He that takes but never gives
May last for years but never lives.

Early to bed and early to rise
Till you make enough money to do otherwise.

It's not the man who knows the most
That has the most to say.

A corkscrew drowns more people
Than a cork belt saves.

A fool and his money soon part at the carnival.

There is free cheese in every trap.

The worst wheel of the cart makes the most noise.

Can't keep a squirrel on the ground.
Can't keep a good man down.

Think of Me Sometimes

Remember me
Whenever you see
A horse's head
Where his tail should be.

If you ever go to France
To see the sights,
Don't fall in a trance
And forget Elizabeth Weitz.

In curve, out curve,
Slow ball, drop,
Don't forget Jim
The star shortstop.

Roses are red,
Violets are blue.
If you forget me
I'll break you in two.

I looked your album o'er and o'er
To see what others wrote before.
Now I write to let others see
Just two words, "Remember me."

Perhaps in some succeeding year
Your eyes may rest a moment here,
And memory will bring back to view
The one who wrote these lines to you.

When you fall down
And skin your knee,
Jump up quick
And think of me.

Peruse these simple rhymes
If ever you read any,
And think of me sometimes
Among the many.

Remember the M,
Remember the E,
Put them together,
Remember ME.

Remember the beer,
Remember the foam,
Remember the night
We carried you home.

Think of me now,
Think of me ever,
Think of the days
We spent together.

Remember the pen,
Remember the ink,
Remember the night
You slept in the sink.

Remember the river,
Remember the rill,
Remember the girl
Who wrote uphill

When you're washing dishes
And are as mad as mad can be,
Just squeeze the old dishrag
And think you're squeezing me.

Your album is a garden
Where all your friends may sow.
I sow the seed Forget-me-not
And hope that it may grow.

When you stand upon the stump
Think of me before you jump.

When you stand before the sink
Think of me before you drink.

When you're sitting all alone
Thinking of the past,
Remember there is one true friend
Whose love will always last.

When I am gone out of your mind
Within this book my name you'll find,
And when my name you plainly see
You can no less than think of me.

When the golden sun is sinking
And your mind from troubles free
When of others you are thinking
Will you sometimes think of me?

Though days be dark
And friends be few,
Remember me
And I will you.

Should old acquaintance be forgot
When years and years have passed?
Bear me in your memory
Up unto the last.

May Your Life
Be like Spaghetti

Excuse the writing,
Blame the pen.
Best wishes, Amen.

May your life be like spaghetti,
long and full of dough.

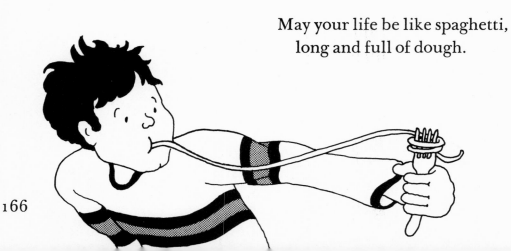

Health and long life to you,
Land without rent to you,
A child every year to you
And may you die in Ireland.

May you never blush although this page is read.

Best wishes too you
from the kid who couldn't spell.

May your coffee and slanders
always be the same—without grounds.

Lots of Luck, Love Larry

May your heart be as light as a snowflake,
May your troubles dissolve like them too,
And a snowstorm of good wishes
I'm hoping may fall upon you.

For 120 years of happiness
 and health.
When used up get refilled by

Jack

The waves of life flow on forever.
May you be on a crest of the waves.

Zee hat comes from gay Paree,
Zee best wishes zey come from me.

Before you journey to the end of life
I hope you'll be a rich man's wife.

May success follow you like a rabbit after carrots.

May we all thrive together
Like bees in a hive
And may we never sting each other.

172

May wisdom attend you
Both early and late
And Heaven assist you
In finding a mate.

HAPPINESS
SUCCESS
SINCERELY
YOURS

165 lbs. of Congratulations.

Rots of Ruck

¿Escribo Yo
En Tu Libro?

¿Escribo yo en tu libro?
¿Que diré?
Solamente dos palabras:
Recuérda me.

Write in your book?
What shall I say?
Only two words:
Remember me.

176

Azul es el cielo
Azul es el mar
Azul es la página
Que voy a firmar.

Blue is the sky
Blue is the sea
Blue is the page
That I'm going to sign.

De las islas Puerto Rico
De los paises el Perú
Y de todas mis amigas
La mas dulce eres tú.

Of the islands, Puerto Rico
Of countries, Peru
And of all my friends,
The sweetest is you.

Si tu tienes una amiga
Que te aprecie más que yo
Que firme en la siguiente página
Con sangre del corazón.

If you have a friend
Who values you more than I
Let her sign on the following page
With heart's blood.

Si tu deseas ser feliz
Sigue mi consejo;
No te cases con un bobo
Ni con un viejo.

If you want to be happy
Follow my advice;
Don't marry a fool
Nor an old man.

Cuando tu digas que sí
Y tu esposo diga no
Coje el palo de la escoba
Y dile "Aqui, mando yo."

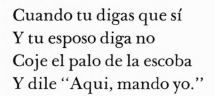

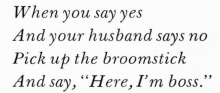

When you say yes
And your husband says no
Pick up the broomstick
And say, "Here, I'm boss."

181

Dios quiera que te cases pronto
Y que tengas diez hijitos
Que te cojan por el traje
Y te sirvan de rabitos.

May God be willing that you marry quickly
And that you have ten little sons
Who will pull you by the skirt
And serve you as little tails.

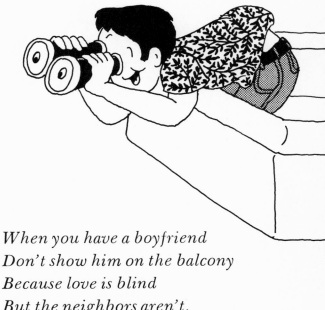

Cuando tengas un novio
No lo saques al balcon
Porque el amor es ciego
Pero los vecinos, no.

When you have a boyfriend
Don't show him on the balcony
Because love is blind
But the neighbors aren't.

Si quieres ser feliz
Y vivir con sabrosura
Ponte la cara muy dura
Y al que te guste dale un beso.

If you wish to be happy
And live with gusto
Be daring
And kiss whomever you please.

Cuando te vayas a casar
Me avisas un dia antes
Para adornarte el camino
De flores y de diamantes.

When you intend to get married
Let me know a day before
So that I may decorate the road
With flowers and diamonds.

Para lograr buena vida
Arte orden y medida.

To achieve a good life
Art, order, and moderation.

En boca cerrada no entran moscas.

Into a closed mouth no flies will enter.

En un cofrecito de oro
Meti la mano y saque
El dulce nombre de Rosa
Que jamas olvidaré.

Into a golden chest
I put my hand and took out
The sweet name of Rose
Which I shall never forget.

Que ojitos, que nariz,
Que boquita para darte un kiss.

What eyes, what a nose,
What a little mouth to give a kiss to.

Napoleón con su espada
Conquistó muchas naciones
Y tu con tus ojos negros
Conquistas los corazones.

Napoleon with his sword
Conquered many nations
And you with your dark eyes
Conquer hearts.

Nunca esperes de la suerte
Ni dinero, ni ventura . . .
Trabaja, niña, si quieres
Ser dueña de una fortuna.

Never trust to luck
For money, for good fortune,
Work, child, if you want
To be mistress of riches.

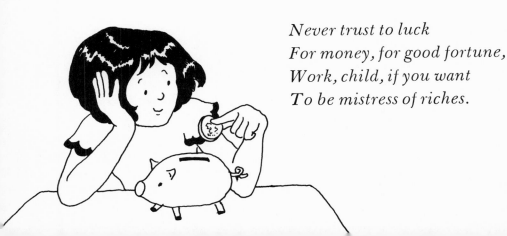

Eres amable
Eres gracioso
Nunca pretendas
Ser orgulloso.

You are kind
You are gracious
Never try
To be conceited.

Un recuerdo tú me pides
Al jardin lo fui a buscar
Y solo pude encontrar
Un ramo de no-me-olvides.

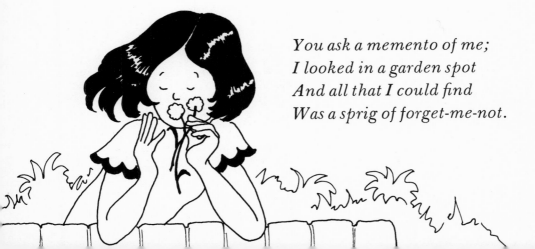

You ask a memento of me;
I looked in a garden spot
And all that I could find
Was a sprig of forget-me-not.

193

Acknowledgments

Albums kindly lent by children and other friends have been the main source for the approximately 325 verses and sayings included here. I wish to thank the following people who contributed autograph books or rhymes: Daisy Aldan, Elaine Armstrong, Eleonora Botti, Cathy Braniff, Lesley Brown, Mary Brown, Ray Brown, Barbara Perkins Brownlow, Miriam Buck, Antonino Casile, Theresa Casile, Delia Davis, Eugene De Blasio, James Edgar Denny, Josephine Diaz, the late Ignatius Duscio, Theodore Ehrsam, Bernard Eisen, Phyllis Fasone, Clara Ferber, Iris Fine, Jean Franchi, M. E. Friel, Lisa Garnek, Murray Gewirtz, Ida Giuffre, Victoria Greenlee, Diane Hanau, Elaine Hanau, Kathleen Hanley, Vicki Harris, Cheryl Hatcher, Janet Hermann, Philomena Houlihan, Yolanda Iacovantuno, Sally-Ruth Isenberg, Theresa Ivanier, Debbie Kavourias, Stephanie Kavourias, Anne Kelly, Gretchen Kelly, Barbara Ketcham, Jean Ketcham, Judy Ann Ketcham, Fay Klein, Tuli Kupferberg, Dorothy Leder, Geraldine Levy, Ellen and John Li Bretto, Fedela Lioy, Lillian Lopez, the late Gerald McDonald, Donna MacIver, Carmine Martino, Concetta Marzullo, Helen Masten, Helen Matthews, Demiana Messineo, Esther Bonilla Miller, Sandi Miller, Elaine Mittelgluck, Vivian Noonan, Mildred

Osipowitz, Carmen Jimenez Paradiso, Octavia Peyton, Jill Price, Lilian Moore Reavin, Carol Reisner, Clara Rees, Doris Ritzmann, Judy Rogers, Henry Rohrig, Sally Schiffman, Adeline and Edward Schultze, Susan Siderman, Elaine Simpson, Toby Victor Sulensky, Gerda Szola, Louise and John Tricard, Deborah Victor, Florence Victor, Esther Jean Walls, Frances Carnes Weintraub, Vivian Weiss, Eva Mae Williams, Henrietta Yurchenko, George Zitwer, and some boys and girls whose names I never knew from Ditmas Junior High School in Brooklyn, and from Jane Addams Vocational High School and Central Commercial High School Annex in New York City.

I am especially grateful to Madeline Braun, and to Lillian Lopez of The New York Public Library for help with Spanish rhymes, to Professor Henrietta Yurchenko of the City University of New York who made available materials collected by her students, to Dr. Elizabeth Pilant and the National Conference American Folklore for Youth at Ball State Teachers College, Muncie, Indiana, for seven selections from their mimeographed collection of American autograph rhymes, and to the following printed sources for several rhymes each:

Dundes, Alan. "Some Examples of Infrequently Reported Autograph Verse." *Southern Folklore Quarterly 26* (1962) :127–130.

Harder, Kelsie B. "A Selection of Youngstown, Ohio, Autograph Verses." Ohio Valley Research Project, The Ross County Historical Society, Chillicothe, Ohio. 1961.

Howard, Dorothy. "Autograph Album Customs in Australia." *Southern Folklore Quarterly 23* (1959) :95.

Wilson, Marguerite Ivins. "Yours Till—; A study of Children's Autograph Rhymes in Utah." *Utah Humanities Review 1* (1947) :245–260.

About the Compiler

Lillian Morrison was born in Jersey City, New Jersey. As a librarian she has worked with young people for many years, and is presently Coordinator of Young Adult Services at the New York Public Library. She is the compiler of several other distinguished anthologies of popular folk rhymes, among them *Yours Till Niagara Falls*, *Black Within and Red Without*, and *Touch Blue*. Miss Morrison is the general editor of the Crowell Poets series and the compiler of *Sprints and Distances*, a book of poems of sport. Her own poems have been widely published, and are collected in two books, *Miranda's Music* and *The Ghosts of Jersey City*.

She was graduated as a Phi Beta Kappa from Douglass College with a B.S. in mathematics and received her library degree from Columbia University. Folklore, poetry, jazz, the dance, and sports are particular interests of hers.

About the Illustrator

Loretta Lustig was graduated from Pratt Institute and has worked as an art director for several advertising agencies. She has illustrated children's books on such widely different subjects as garbage and the metric system. Ms. Lustig enjoys reading odd things, making odd things, and collecting odd things, and she lives in Brooklyn, which she has found to be the ideal place.